# EX LIBRIS

EL VALEROSISIM MARTIR S. GEORGE. F.ABADAL E.MOYA

_____

NAME

# Learn to Draw Like the Masters

# DRAGONS

## Collected Manuscripts Detailing The Masters' Secrets For Studying And Drawing Dragons

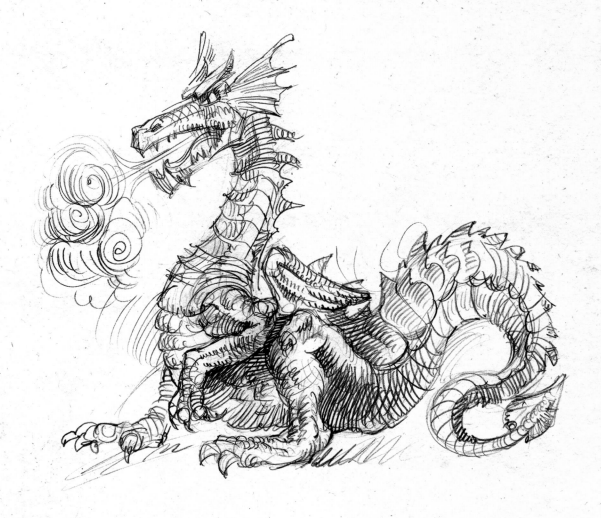

BY EUGENE CAINE

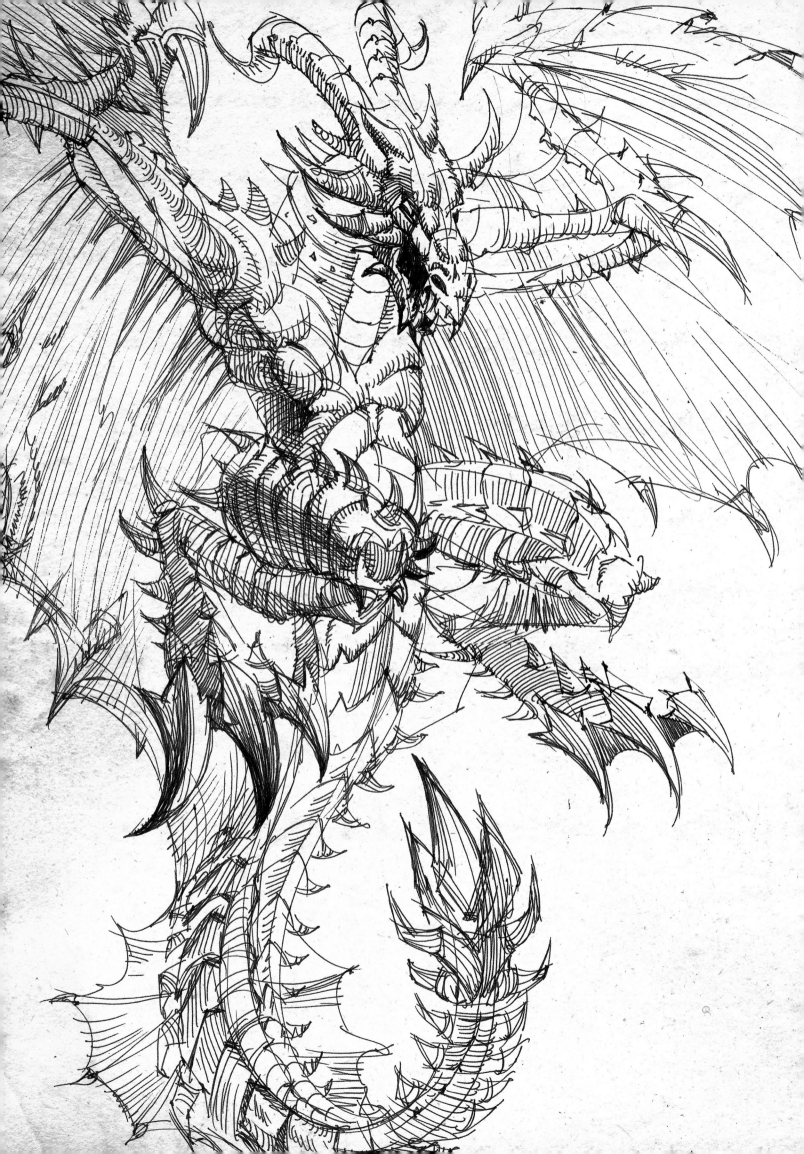

# TABLE OF CONTENTS

# Dear Good Reader,

Twenty years ago while unearthing a collection of my grandfather's manuscripts from deep in the basement of his castle, I discovered a guide detailing the artistic secrets of the great masters. They changed my life and the lives of everyone I love. Here I share them with you. As many pages of the original manuscript were damaged, I have tried to reconstruct the precious instruction they contained to the best of my ability, drawing on the creative wisdom passed down to me through my father and grandfather.

Furthermore, amidst the manuscripts lay an even more unexpected discovery—field notes that suggest some of the great masters actually encountered dragons! As a child I heard the legends of dragons and other fantastical creatures, but with the excavation of these master works, I was inspired to begin my own hunt for a beast I never believed could exist. And, good reader, they most certainly exist! After encountering and studying a range of species, I now want to pass the secrets of the dragon world on to the next generation. I know you will find that not only do dragons often guard valuable treasures—they are a rewarding subject of study with their incredible powers and ancient customs.

I could fill a hundred books with details about these magnificent creatures, but this guide will give you everything you need to know to begin your own quest to learn about and depict dragons.

You are entering a noble tradition. Observe your subjects with care, enjoy the adventure, be safe, and guard these secrets well!

*Eugene Caine*

# MEETING THE MASTERS

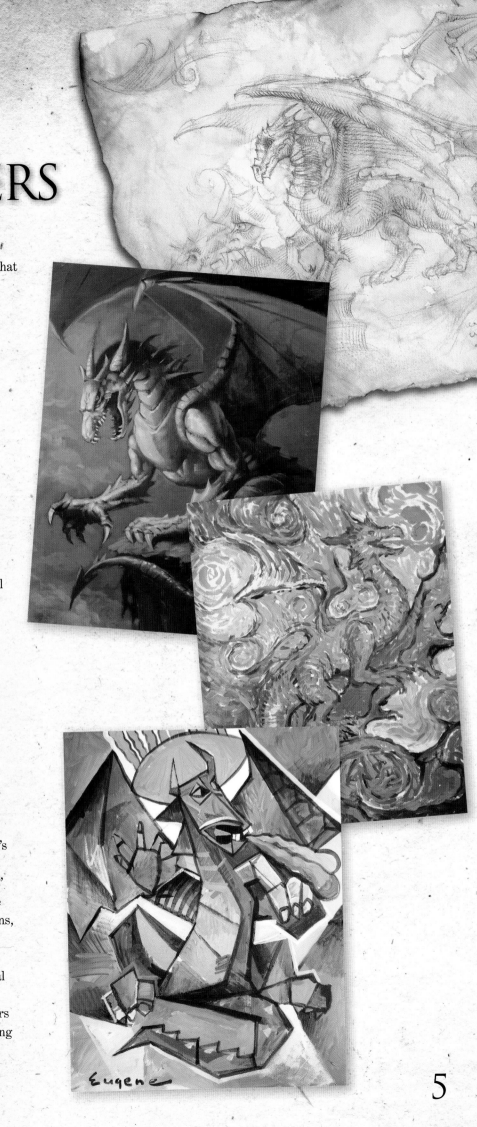

**W**ho are these master artists whose secrets will illuminate the darkest of dragon caves? Theirs are the names that echo through history—Leonardo Da Vinci, Peter Paul Rubens, Vincent Van Gogh, Pablo Picasso.

A creative genius with a passion for scientific inquiry and discovery, Da Vinci is the perfect guide for drawing dynamic anatomical forms. His notebooks are filled with studies of human and animal figures. Develop your own artistic abilities with Da Vinci's masterful pencil strokes and delve into the world of dragons by following his investigative spirit!

To portray your dragon subjects in their full, three-dimensional glory, use Rubens' painting techniques for sculpting forms out of light and shadow. Rubens was a well-traveled diplomat and linguist from whom we could learn invaluable information about dragons, if only he were alive. However, we can look to his vivid and dimensional painting style in our depiction of dragons.

As dragonologists, we are reminded daily of these amazing creatures' strong connection to nature. Explore a dragon's energy and primal essence through the movement and bold color contrasts of Van Gogh's impressionistic paint strokes. Immersing yourself in Van Gogh's style sharpens your senses and ability to express your field observations on the canvas.

The modern dragonologist, such as yourself, may choose to study dragons from a fresh perspective. I recommend using Picasso's method of deconstructing forms into geometrical shapes to better understand the subtle nuances in a dragon's physical and psychological states.

Within these pages, these four master artists' secrets are revealed! Begin by learning about the history of dragonology, different species of dragons, and practical guidelines for working in the field. Next practice basic drawing and color techniques for rendering dragons, and explore the anatomical structures of dragons. Then discover the tools, techniques, and unique style of each of the masters through detailed, step-by-step projects for creating dragon portraits.

LEARN TO DRAW LIKE THE MASTERS

# THE STUDY OF DRAGONS

Although many would argue that the existence of dragons is mere myth, history provides too much evidence to the contrary. I am afraid dragons are as real as you and I. And as modern dragonologists, we should look to our exceptional predecessors to guide us in our study of these powerful creatures.

## RENOWNED DRAGONOLOGISTS

The ancient sage Fu Hsi is commonly revered as the father of dragonology and the methods he developed for communicating with dragons are still used today. While contemplating the welfare of his beloved subjects, legendary Chinese emperor Fu Hsi encountered an ancient dragon on the banks of the river Luo. Upon studying the celestial trigrams of divination on the dragon's back, Fu Hsi discovered the I Ching philosophy and the secret to writing. He used this knowledge to teach his people how to coexist peacefully, domesticate animals, and make music. Fu Hsi also instituted the practice of marriage, seeking to bring the balance of yin and yang into the home. The Chinese associate dragons with good fortune, power, divinity, and wisdom. Chinese emperors were thought to be the descendents of dragons and those born in the zodiac year of the dragon are said to be lucky, charismatic, and generous.

Merlin Ambrosius, best known as King Arthur's advisor, also obtained crucial information from dragons. As a small boy, Merlin was summoned to King Vortigern's court when construction on a fortress was repeatedly delayed by mysteriously collapsing walls. The young prophet Merlin explained to King Vortigern that beneath the fortress site lay a pool of water, under which two restless dragons fought with one another. Merlin predicted that the final victor in the battle between the red and white dragons trapped underground would determine the fate of Wales.

Of course, all dragonologists owe a debt of gratitude to the 16th century naturalist Edward Topsell. The author of *History of Four-Footed Beasts and Serpents,* he pioneered techniques in tracking, observation, and documentation. Topsell was one of the first dragonologists to scientifically explore the link between reptiles and dragons.

And though she was not famous, I must note that my great aunt Zofia was an inspiration, always ready for an adventure, and a leader in the progressive movement to protect dragons and prevent their extinction. She died tragically on our last Arctic expedition—the breath of the Yilbegan dragon is especially vicious. I miss her every day.

## THE DRAGONSLAYERS

In many western cultures, dragons have often been regarded—unfairly, in my opinion—as destructive enemies of humankind. Wouldn't *you* retaliate after encountering humans who sought you out with murderous and avaricious intent? Whatever the case may be, I must mention a few famous dragon slayers who have made it into the annals of dragonology history.

Although many men have claimed to, only Hercules has slain a hydra with more than nine heads. As one of the twelve labors imposed upon him for murdering his family in a fit of madness, Hercules was sent to slay the venomous Hydra that allegedly terrorized the town of Lerna. With the assistance of his loyal nephew Iolaus, Hercules defeated the immortal, multi-headed dragon.

Other historical figures known for saving towns from violent dragons include Danish King Beowulf, St. George of Cappadonia, and Austrian giant Haymo. However, destructive behavior is not common amongst most dragon species, as dragons are private creatures that tend to avoid human contact.

*Although most dragon species do not display violent tendencies, dragonologists should go into the field with caution. Considering the history of dragon slayings, these creatures are suspicious of humans and may view you as a threat to their offspring or the treasures they protect. Always carry a sword or dagger in case you are forced to fend off an angry dragon, and be sure to keep away from its sharp claws and snout (if it is a fire breather). Recite the following calming spell while waving your sword in a figure-eight movement: "Oh great wise one, I mean no harm. In peace and amity, I cast this charm." When the dragon's eyes glaze over and its movements slow, grab your supplies and put as much distance between yourself and the dragon as possible. Please note that the calming spell's effects wear off in 10–15 minutes.*

# DRAGONS AROUND THE WORLD

One could devote an entire lifetime to the study of dragons and still remain ignorant of the vast range of draco species in existence. Dragons are resilient creatures that have adapted to every habitat on earth—from the arctic glaciers of Greenland to the tropical rainforests of South America. Here are just a few of the major types of dragons across the world.

### FALCONI DRACO

*Habitat & Range: Rocky outcroppings near seacoasts, rivers, large lakes, and other open bodies of water in Alaska and the American northwest.*

### DEEP SEA DRAGON

*Habitat & Range: Deep ocean waters at depths of up to 5,000 feet where other bioluminescent life forms exist*

### FRIGATE DRACÓN

*Habitat & Range: Nests along the Brazilian coast and on the Galapagos Islands*

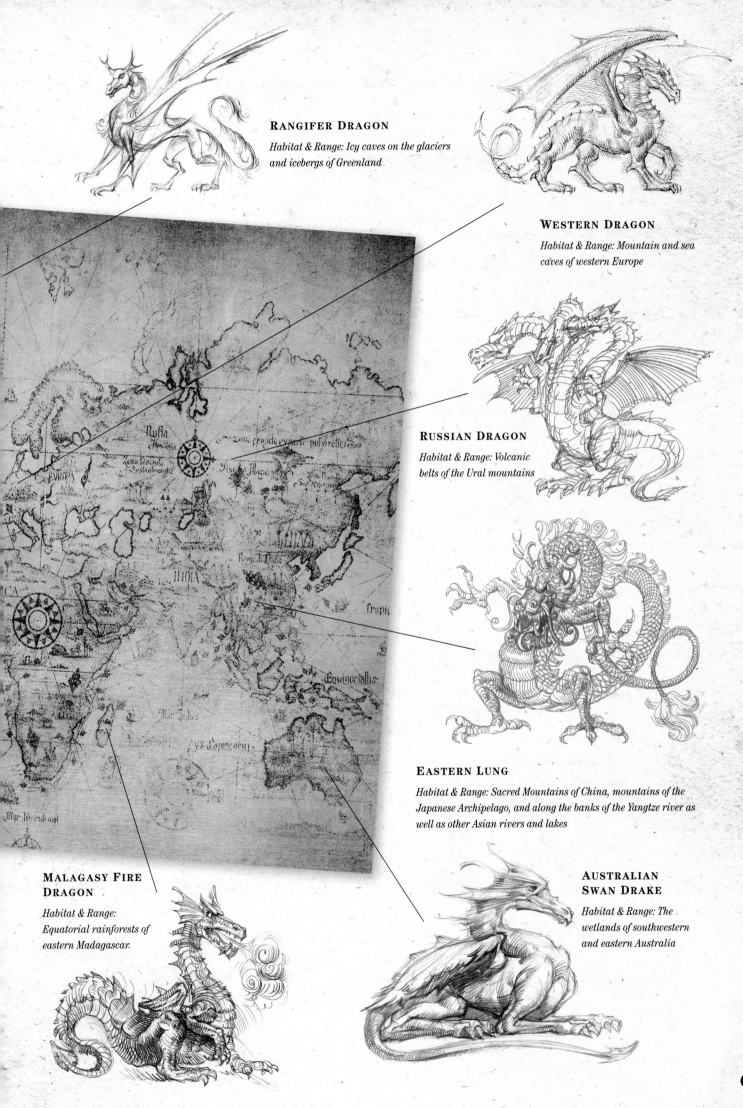

**RANGIFER DRAGON**

*Habitat & Range: Icy caves on the glaciers and icebergs of Greenland*

**WESTERN DRAGON**

*Habitat & Range: Mountain and sea caves of western Europe*

**RUSSIAN DRAGON**

*Habitat & Range: Volcanic belts of the Ural mountains*

**EASTERN LUNG**

*Habitat & Range: Sacred Mountains of China, mountains of the Japanese Archipelago, and along the banks of the Yangtze river as well as other Asian rivers and lakes*

**MALAGASY FIRE DRAGON**

*Habitat & Range: Equatorial rainforests of eastern Madagascar*

**AUSTRALIAN SWAN DRAKE**

*Habitat & Range: The wetlands of southwestern and eastern Australia*

LEARN
TO DRAW
LIKE THE
MASTERS

# A DRAGONOLOGIST'S FIELD GUIDE

I f you are serious about the scientific study of dragons, you need to know a few basic guidelines—where to find dragons, what you should bring on your expeditions, and how to record your findings.

## IN SEARCH OF DRAGONS

Dragons create their lairs in remote areas with treacherous terrain, such as swamps, mountains, volcanoes, forests, and underground caves. Getting lost in these inhospitable settings would be very unpleasant indeed. So venture forth into the field with a trusty compass and detailed maps! Fact-check every lead you come across before planning any trips, as many accounts of dragon sightings are hoaxes or the recollections of inebriated campers who mistake larger wildlife for dragons.

ITALIA
900

BOLOGNA
PINACOTECA NAZIONALE

## ESSENTIAL SUPPLIES

In addition to maps and a compass, be sure to pack clothing appropriate to the weather conditions of your destination and a pair of sturdy hiking boots that have already been broken in. Bring portable art supplies for drawings and quick paintings, a notebook and pens for field notes, and candles for lighting. I usually take empty jars and a magnifying glass with me for collecting and examining specimens. A bedroll and fold-out chair are also highly recommended, as you may have to camp out for days before a dragon returns to its lair. And plenty of coffee, water, and snacks will keep you energized and alert for your exciting task. As mentioned earlier, you should keep a knife and spellbook on hand in the event that you encounter an agitated dragon.

## EFFECTIVE FIELD NOTES

As the rest of this manuscript deals primarily with the great masters' artistic techniques and tips on creating dynamic dragon portraits, I would like to take a moment to focus on your written field notes, which should carry the same authority as your drawings. It can be difficult to record detailed notes when you are in a dragon's lair or stationed on a precarious mountainside lookout, so I suggest quickly jotting down and sketching what you see. You can clarify these notes and rough sketches later when you transcribe your observations in a quiet and comfortable workspace. Your colleagues in the field will appreciate the care you take in documenting your dragon studies.

# PENCIL TECHNIQUES

Dragons offer the artist an array of textures to recreate. To begin drawing these magnificent creatures, find a pencil grip that is comfortable for you. Experiment with different types of lines and grades of pencils to learn how to control your strokes and achieve a variety of tones. Next practice observing and drawing simple objects and people before attempting to depict a dragon that is less likely to stay still long enough for you to complete a drawing. Squint your eyes, paying attention to the *value* (the relative darkness or lightness of a color or of black) of the *highlights* (where light strikes an object) and shadows of your subject. Shading your drawing according to these value differences will create the illusion of depth and three-dimensional form.

### HOLDING THE PENCIL

*Some artists prefer an underhand grip (top, right), that is great for even, solid shading and soft blending. The traditional overhand grip (right) may provide more mechanical control for firm and precise pencil strokes.*

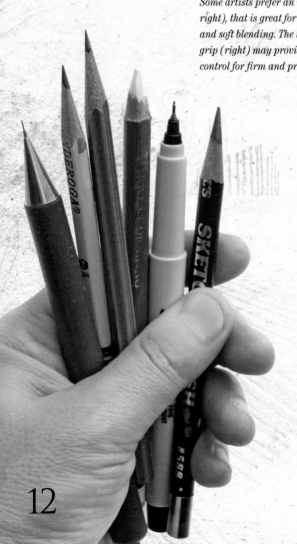

### VALUE SCALE

*Making your own value scale, such as the one shown above, will help familiarize you with the different variations in value. Work from light to dark, adding more and more tone for successively darker values. Different pencils produce varying value ranges; this scale was drawn with a standard HB pencil.*

### BASIC DRAWING TOOLS

*Each of the master artists' tools are detailed in the following projects, but you should keep a variety of pencils and pens on hand. I recommend trying different sketching, graphite, charcoal, mechanical, and white pencils. You may also want to use a pen for inking your finished drawings.*

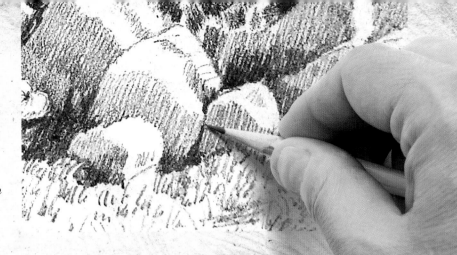

## HATCHING

The most basic method of shading is to fill an area with hatching, or a series of parallel pencil strokes created using an even, back-and-forth motion.

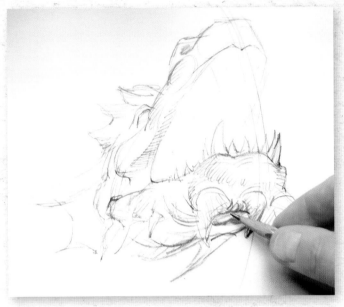

## CREATING VOLUME

When shading, follow the curves and planes of the different parts of a subject. Notice how the hatch marks on the upper jaw, lower jaw, and horns go in different directions, giving volume to this rough sketch.

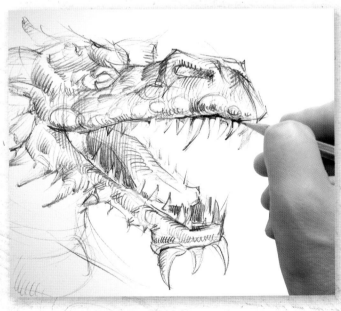

## DEFINING TOUCHES

Draw lines that suggest motion, such as the vertical strokes between the upper and lower jaw, and around the bottom front teeth. Darken tiny areas for greater contrast and definition. See the teeth, snout, and horns above.

## CREATING DRAGON TEXTURES

Spines, scales, feathers, and hair are just a few of the features found on dragons. Use different types of lines and shading techniques to render the distinct textures of dragons.

For even, rough scales, create a grid and treat each scale as an individual form. Sketch out general shapes and fill in the shadowed sides with hatching.

Use soft, curving strokes for the bushy tail of an Eastern Lung. Vary the direction of your pencil strokes to indicate separate locks of hair.

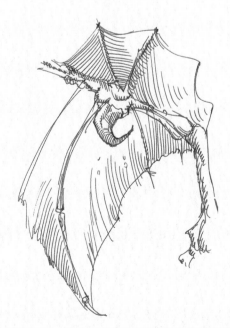

Some dragons have thin, gossamer wings. Define these wings with just a few light strokes. You may also add a few small circles to show their transparency.

13

# BASIC SHAPES AND 3-D FORMS

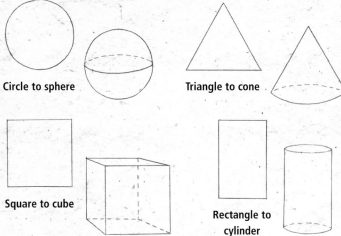

**Circle to sphere**

**Triangle to cone**

**Square to cube**

**Rectangle to cylinder**

At first glance, a dragon may seem like a complex drawing subject. However, breaking it down into simple *forms*, or three-dimensional shapes, can make the drawing process more manageable. Start with the four basic shapes—circles, rectangles, squares, and triangles. Their corresponding forms are spheres, cylinders, cubes, and cones. Every object and body part can be simplified into basic forms. For example, a ball and an eye are both spheres, and a tree trunk and leg are cylinders. To draw a dragon, just sketch the shapes, develop the forms, and refine the details!

### TRANSFORMING SHAPES INTO FORMS

*Here I've drawn the four basic shapes and their respective forms. I think of the shapes as flat frontal views of the forms; when tipped, they appear as three-dimensional forms. Use ellipses to show the backs of the circle, cylinder, and cone; draw a cube by connecting two squares with parallel lines.*

### FOOT SHAPES

*Draw the foot with triangles and rectangles, sketching each part as a simple shape.*

### EYE SHAPES

*Start the eye with a circle and draw a second, inner circle for the iris. Add a line bisecting the circles that determines the placement of the eye corners.*

### FOOT FORMS

*Develop the claw and heel triangles into cones and make each toe segment a cylinder.*

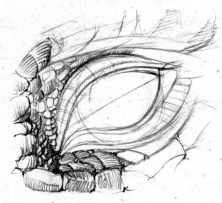

### EYE FORMS

*As you develop the eye, lids, and surrounding scales, it begins to appear three-dimensional, its basic circle shape taking on the form of a sphere.*

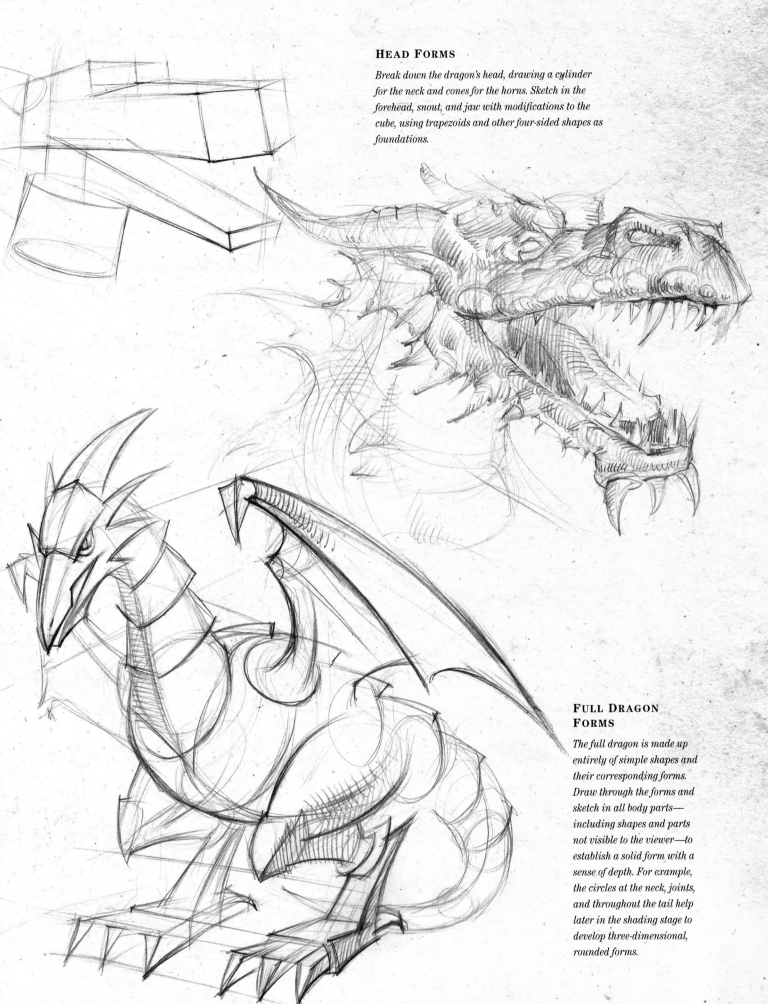

## HEAD FORMS

*Break down the dragon's head, drawing a cylinder for the neck and cones for the horns. Sketch in the forehead, snout, and jaw with modifications to the cube, using trapezoids and other four-sided shapes as foundations.*

## FULL DRAGON FORMS

*The full dragon is made up entirely of simple shapes and their corresponding forms. Draw through the forms and sketch in all body parts— including shapes and parts not visible to the viewer—to establish a solid form with a sense of depth. For example, the circles at the neck, joints, and throughout the tail help later in the shading stage to develop three-dimensional, rounded forms.*

15

# PERSPECTIVE

Employ the rules of perspective to create the impression that your dragon drawings inhabit a three-dimensional space with depth and distance. The most important rule of perspective is that objects close to the viewer are larger than objects farther away. In addition to creating realism, perspective is also used to keep all elements on the picture plane in proper proportion.

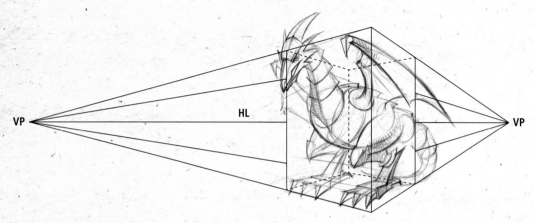

VP    HL    VP

## TWO-POINT PERSPECTIVE

*In two-point perspective, there are two vanishing points (VPs). A three-dimensional cube best demonstrates this concept. First draw a horizon line (HL), and place one VP at the far left and another VP at the far right. VPs are always on the HL at the viewer's eye level. Draw a 90-degree center "post" that extends above and below the HL at an equal distance. Draw lines from the top and bottom of the post that extend to each VP. Add two more vertical lines to the left and right of the center post to represent the corners of your cube. At the point where each corner post intersects the VP lines, draw a new line back to the opposite VP. These lines form the back edges of your cube, and the place where they intersect is the back corner post. The perspective of the VPs affect the position of the dragon within the cube above.*

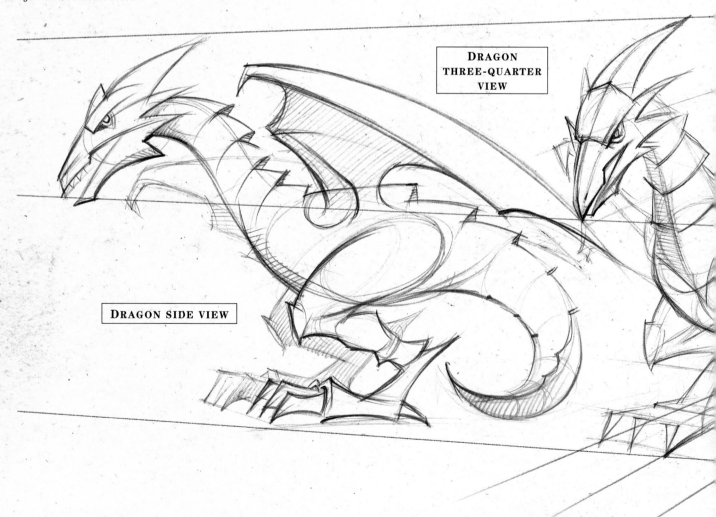

DRAGON
THREE-QUARTER
VIEW

DRAGON SIDE VIEW

# FORESHORTENING

Foreshortening works hand-in-hand with perspective in contributing to a drawing's sense of depth, following the rule that the part of the subject closest to the viewer appears larger than the parts that are farther away. Shortening the lines on the sides of the object closest to the viewer helps create this illusion.

### RECOGNIZING FORESHORTENING

*This sketch of a dragon's head is a good example of foreshortening. Notice how the dragon's lower jaw is larger than the upper jaw because it is closer to the viewer. In the basic forms sketch at left, the cylinder for the neck tapers upward as it moves further from the viewer.*

DRAGON FRONT VIEW

17

# COLOR THEORY AND PALETTES

K nowing a little about color theory will help you mix colors and capture the diverse colors of dragons. All colors are derived from three *primary* colors—red, yellow, and blue. (The primaries can't be created by mixing other colors.) *Secondary* colors (orange, green, purple) are each a combination of two primaries, and *tertiary* colors (red-orange, red-purple, yellow-orange, yellow-green, blue-green, blue-purple) are the results of mixing a primary with a secondary. *Hue* refers to the color itself, such as red or green, and *intensity* means the strength of a color, from its pure state to one that is grayed or diluted. Varying the values of your colors allows you to create depth and form in your paintings. (See page 12 for more information on value.)

## COLOR WHEEL

A color wheel (or pigment wheel) is a useful reference tool for understanding color relationships. Knowing where each color lies on the wheel makes it easy to understand how colors relate to and react with one another. Whether they're opposite one another or next to one another will determine how they react in a painting—which is an important part of evoking mood in your paintings. (See the following sections on color psychology and complements versus analogous colors.)

## COLOR PSYCHOLOGY

Colors are referred to in terms of "temperature," but that doesn't mean actual heat. An easy way to understand color temperature is to think of the color wheel as divided into two halves: The colors on the red side are warm, while the colors on the blue side are cool. As such, colors with red or yellow in them appear warmer. For example, if a normally cool color (like green) has more yellow added to it, it will appear warmer; and if a warm color (like red) has a little more blue, it will seem cooler. Temperature also affects the feelings colors arouse: Warm colors generally convey energy and excitement, whereas cooler colors usually evoke peace and calm. This explains why bright reds and golds are used in royal settings and greens and blues are used in bathhouses and sitting rooms.

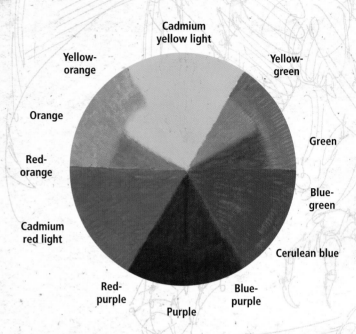

**WARM COLOR WHEEL**

*The color wheel above shows a range of colors mixed from warm primaries. Here you can see that cadmium yellow light and cerulean blue have more red in them (and that cadmium red has more yellow) than their cool counterparts in the wheel below do.*

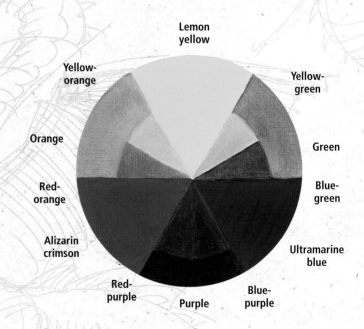

**COOL COLOR WHEEL**

*This cool color wheel shows a range of cool versions of the primaries, as well as the cool secondaries and tertiaries that result when they are mixed.*

# COMPLEMENTARY AND ANALOGOUS COLORS

*Complementary* colors are any two colors directly across from each other on the color wheel (such as purple and yellow). When placed next to each another in a painting, complementary colors create lively, exciting contrasts, as you can see in the examples at right.

*Analogous* colors are those that are adjacent to one another (for example, yellow, yellow-orange, and orange). And because analogous colors are similar, they create a sense of unity or color harmony when used together in a painting.

## COMPLEMENTARY COLORS

*Here are three examples of complementary pairs. Using a complementary color in the background will cause your subject to seem to "pop" off the canvas. For example, place bright orange flames against a blue sky, or enliven a green dragon by placing it against a fiery red sunset.*

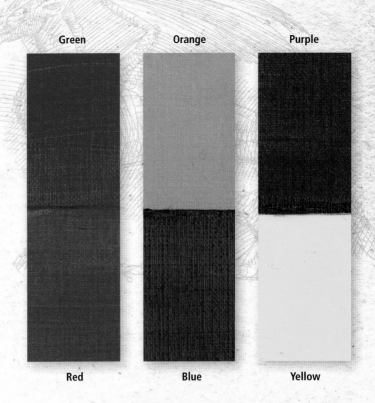

Green     Orange     Purple

Red     Blue     Yellow

# COLOR PALETTES OF THE MASTERS

In addition to special drawing and painting techniques, you will discover the color secrets of the masters. Most of your drawings will be quick pencil or ink studies done in the field. However, creating a finished painting gives you a deeper glimpse into a dragon's mind. Here is an overview of Rubens, Van Gogh, and Picasso's distinct color palettes. You will learn more about each of these master's styles and use of color later, and I encourage you to experiment with other color combinations as well. Always assess your dragon subject's actual appearance, surroundings, and personality before deciding on the most appropriate color palette.

## RUBENS' PALETTE

*Rubens' palette consists of warm, earthy browns, reds, and flesh tones. Cool blue-green shadows add contrast and build up depth in Rubens' robust anatomical forms.*

## VAN GOGH'S PALETTE

*Van Gogh's use of expressive color features bold primary colors and complementary pairs. Color represents emotion rather than subjects' actual appearance in Van Gogh masterpieces.*

## PICASSO'S PALETTE

*Picasso offers an even greater departure from traditional, representational color. Flat, geometric areas of pattern and varied colors are used to redefine forms, rather than realistically describe them.*

# DRAGONS, A NATURAL HISTORY

Dragons possess similarities to mammals, reptiles, and birds, but belong to a class of their own. They are warm-blooded, *oviparous* (egg-laying) *vertebrates* (animals with backbones), and many draco genera can fly.

## SKELETAL STRUCTURE

Like mammals, dragons have seven cervical vertebrae, or neck bones. A cervical girdle encases the throat and upper bronchial sac of breath dragons. Most dragons have four limbs, in addition to a pair of wings, although some species have other physiological adaptations. For example, the Deep Sea Dragon has flipper-like appendages in place of wings and the Eastern Lung does not possess wings.

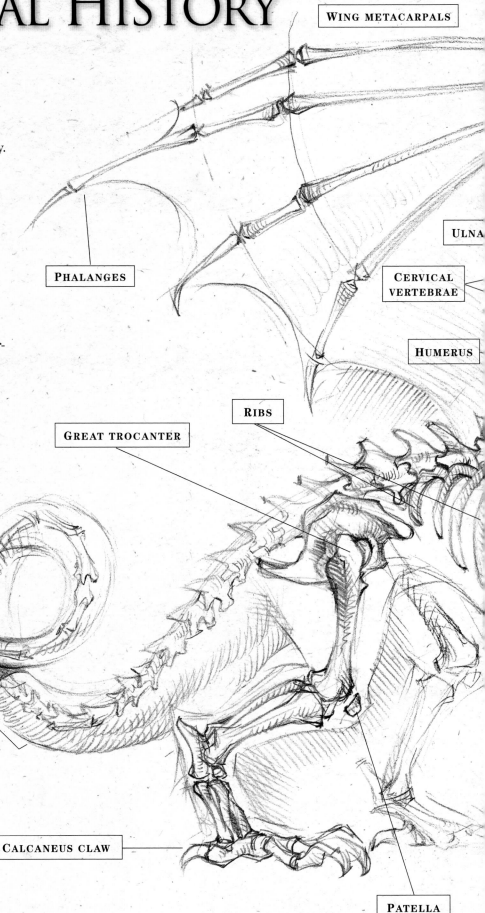

WING METACARPALS

PHALANGES

ULNA

CERVICAL VERTEBRAE

HUMERUS

RIBS

GREAT TROCANTER

CLAUDAL SPEAR

CLAUDAL VERTEBRAE

CALCANEUS CLAW

PATELLA

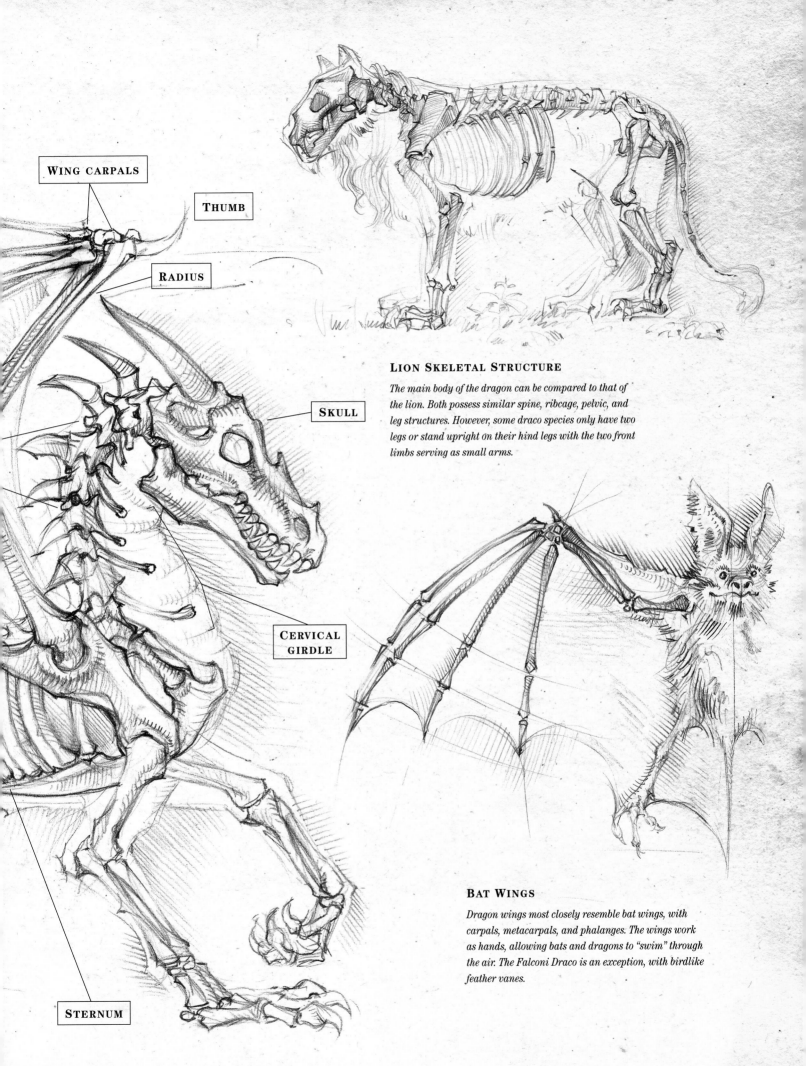

**WING CARPALS**

**THUMB**

**RADIUS**

**SKULL**

**CERVICAL GIRDLE**

**STERNUM**

## LION SKELETAL STRUCTURE

*The main body of the dragon can be compared to that of the lion. Both possess similar spine, ribcage, pelvic, and leg structures. However, some draco species only have two legs or stand upright on their hind legs with the two front limbs serving as small arms.*

## BAT WINGS

*Dragon wings most closely resemble bat wings, with carpals, metacarpals, and phalanges. The wings work as hands, allowing bats and dragons to "swim" through the air. The Falconi Draco is an exception, with birdlike feather vanes.*

# MUSCULAR STRUCTURE

Dragons are some of the most powerful animals on earth. The Acinonyx Dragon can run up to 85 miles per hour, with vigorous vastus and gastrocnemius muscles. In the air, there are few creatures that can keep up with the Frigate Dracón, whose aerobrachioradialis is equal to its bicep in size and strength. The muscles in a dragon's hands and feet are similar to those in a human hand, allowing dragons the dexterity to grasp prey, scale steep inclines, and even write!

**AEROBRACHIORADIALIS**

**LATISSIMUS DORSI**

**GLUTEUS MAXIMUS**

**ADUCTOR**

**VASTUS EXTERNUS**

**GASTROCNEMIUS**

**TIBIALIS ANTERIOR**

**ACHILLES TENDON**

### TAIL MUSCLES

*A dragon's tail moves much like a snake's body. A series of muscle contractions whips the tail around in S-shaped movements.*

22

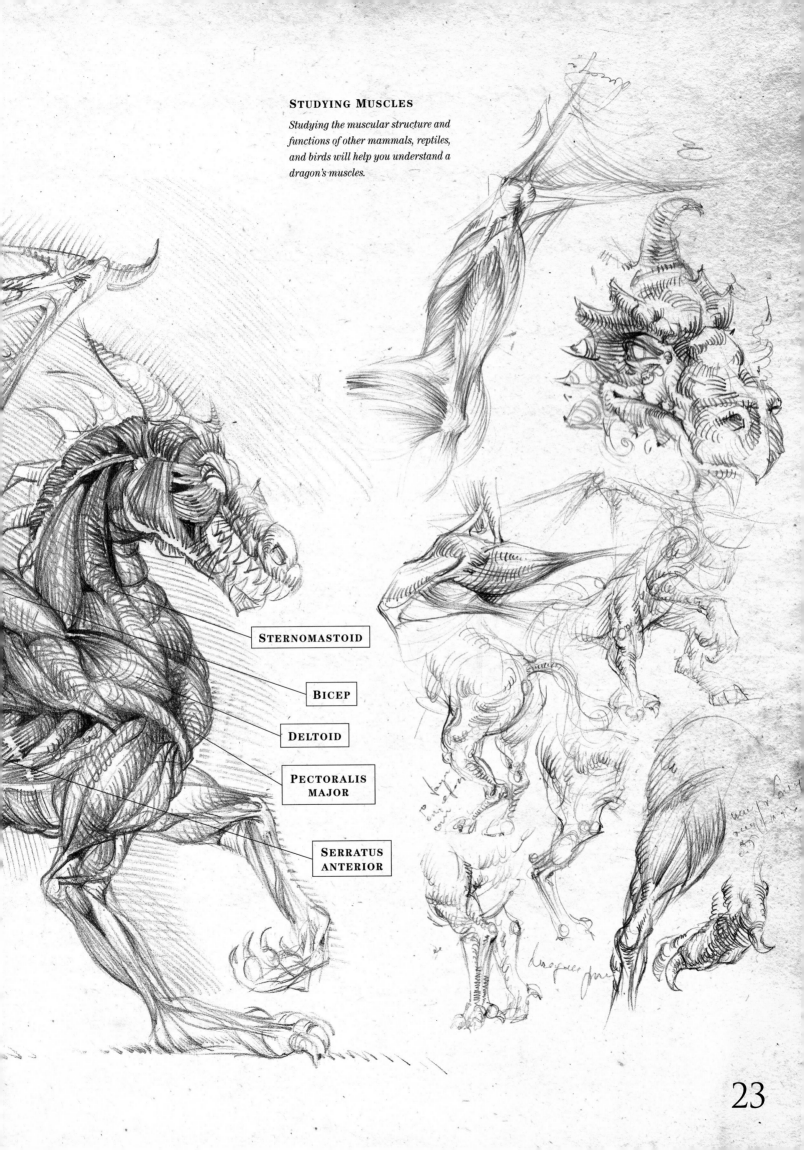

## STUDYING MUSCLES

*Studying the muscular structure and
functions of other mammals, reptiles,
and birds will help you understand a
dragon's muscles.*

**STERNOMASTOID**

**BICEP**

**DELTOID**

**PECTORALIS
MAJOR**

**SERRATUS
ANTERIOR**

## SKIN, SCALES, AND DETAILS

Most dragon bodies are protected by bumpy scales, like those found on lizards, and their tails often feature flatter scutes for snakelike movements. However, some species are covered in fishlike scales, fur, or tough layers of collagen. Dragon wings are usually webbed with a thin membrane of skin, although a few draco genera have feathered wings or more diminutive, non-functional wings. The horns and claws of dragons are made of keratin—the same material found in human nails and hair. I recommend keeping a wary distance from these sharp body parts, as well as the teeth and snouts of fire- or gas-breathing dragons!

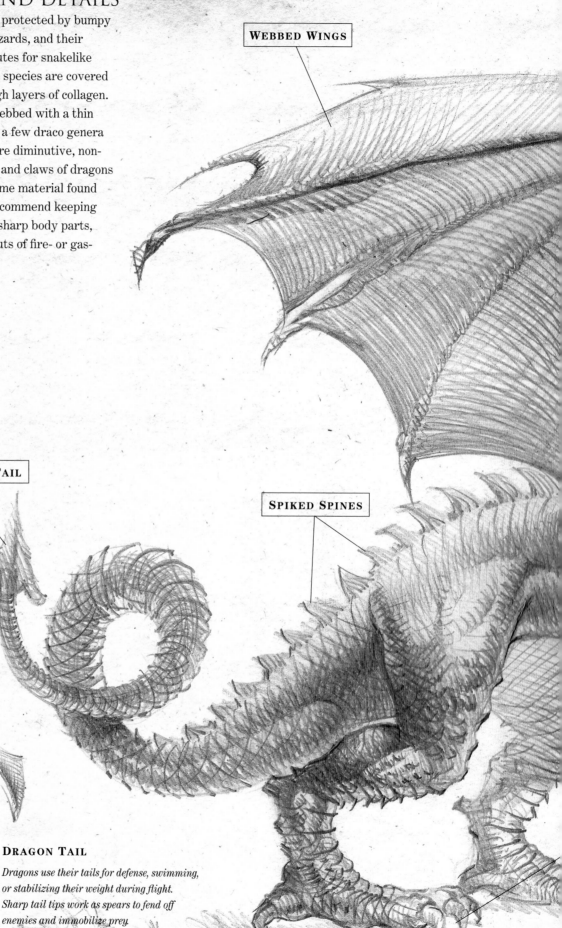

**WEBBED WINGS**

**SPEAR-SHAPED TAIL**

**SPIKED SPINES**

### DRAGON TAIL

*Dragons use their tails for defense, swimming, or stabilizing their weight during flight. Sharp tail tips work as spears to fend off enemies and immobilize prey.*

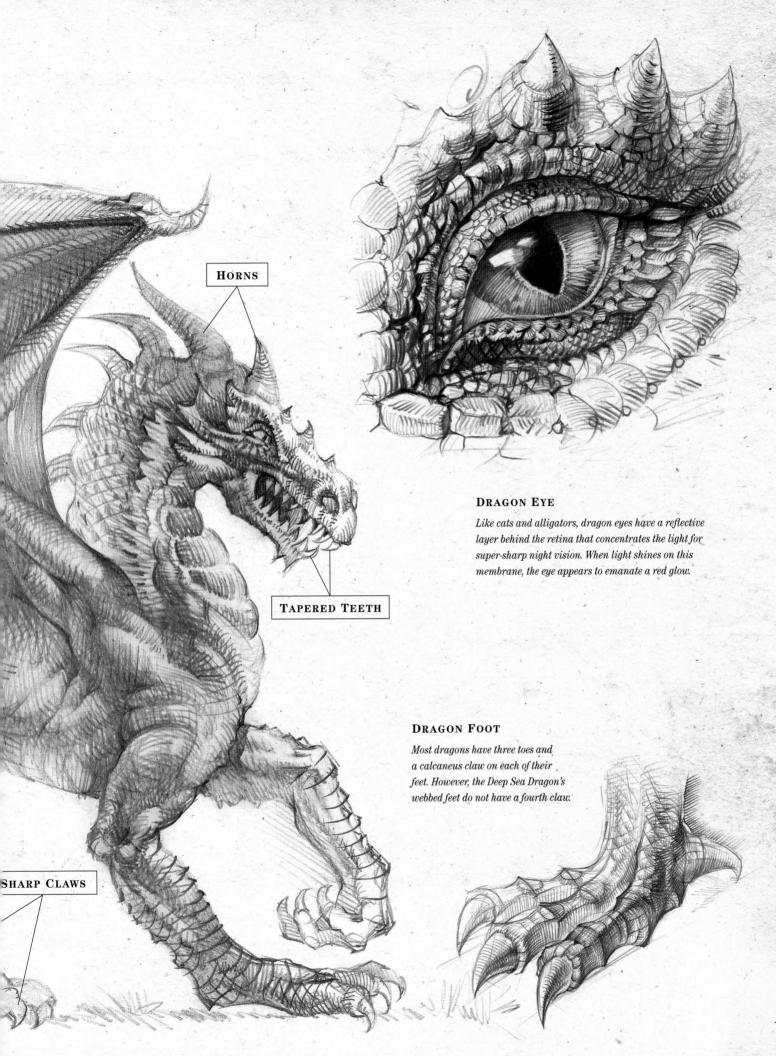

**HORNS**

**TAPERED TEETH**

**SHARP CLAWS**

### DRAGON EYE

*Like cats and alligators, dragon eyes have a reflective layer behind the retina that concentrates the light for super-sharp night vision. When light shines on this membrane, the eye appears to emanate a red glow.*

### DRAGON FOOT

*Most dragons have three toes and a calcaneus claw on each of their feet. However, the Deep Sea Dragon's webbed feet do not have a fourth claw.*

25

# STUDYING DA VINCI'S STYLE

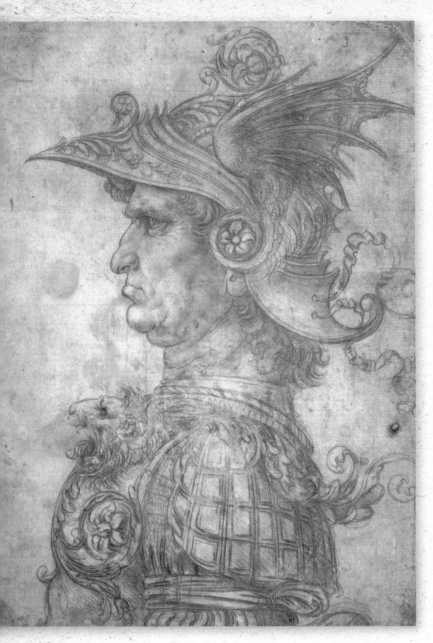

*Leonardo Da Vinci, **Bust of a Warrior in Profile**, ca. 1475–80. Silverpoint drawing. Courtesy of Dover Publications, Inc. (Image from **Leonardo Da Vinci Treasury**.)*

*A favorite tool of Da Vinci's was the goose feather nib dipped in ink.*

Modern artists often struggle to create the illusion of perfection, using erasers, correction fluid, and multiple drafts. True masters, however, understand that the evolution of the drawing should be valued. Layering lines upon lines reveals the artist's process as he captures the subject. This is especially true in fieldwork when observing a new species, or depicting the alien characteristics of some of the more Jurassic dragons.

## STUDYING THE DRAGON ELEMENTS

*This panel of the helmet is eerily similar to the Western dragon's wing structure.*

*The tip of the helmet resembles the scales and tail of the dragon.*

*This detail of the lion's head from the breastplate parallels the ferocious snout of the Western dragon.*

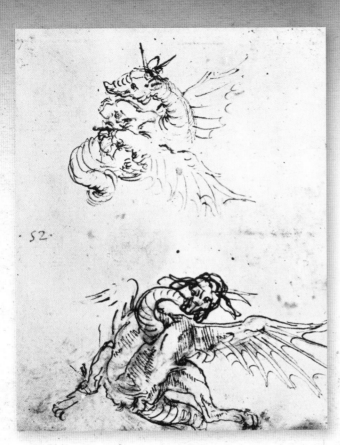

*From the sketchbook of Leonardo Da Vinci. Courtesy of Dover Publications, Inc. (Image from **Leonardo Da Vinci Treasury.**)*

Layering pencil strokes, as demonstrated in my study of the elusive dragon on page 32, is a process similar to the *sfumato* technique that Da Vinci developed for creating a smooth, blended effect. Meaning "soft fog" in Italian, paintings made in the *sfumato* tradition use a brush covered with a light wash of ink to build up color layer by layer, working ever so slowly to reveal the nature of the subject. Artists also use this technique when drawing. I find this technique especially helpful when working in rushed circumstances, as often happens during fieldwork.

### TRADITIONAL TOOLS OF THE MASTERS

*As pencils were not invented until the 16th century, Da Vinci and other artists of his time used a metalpoint, a drawing instrument with a sharp metal tip—silverpoint was popular, as it produced the most permanent results. They also used charcoal or sanguina, a red clay crayon, for drawings. A favorite tool of Da Vinci's was the goose feather nib dipped in ink. Artists mixed their own inks with organic materials, such the dark substance excreted by cuttlefish that was used to form sepia, a reddish-brown ink. Da Vinci also added finishing accents to his drawings with white chalk.*

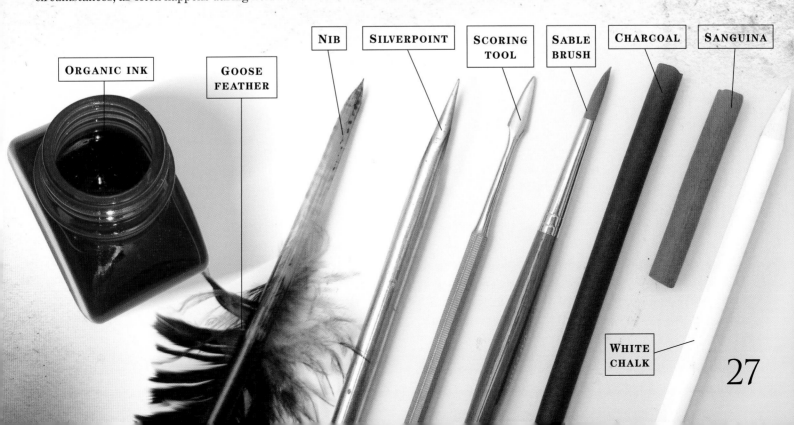

ORGANIC INK · GOOSE FEATHER · NIB · SILVERPOINT · SCORING TOOL · SABLE BRUSH · CHARCOAL · SANGUINA · WHITE CHALK

27

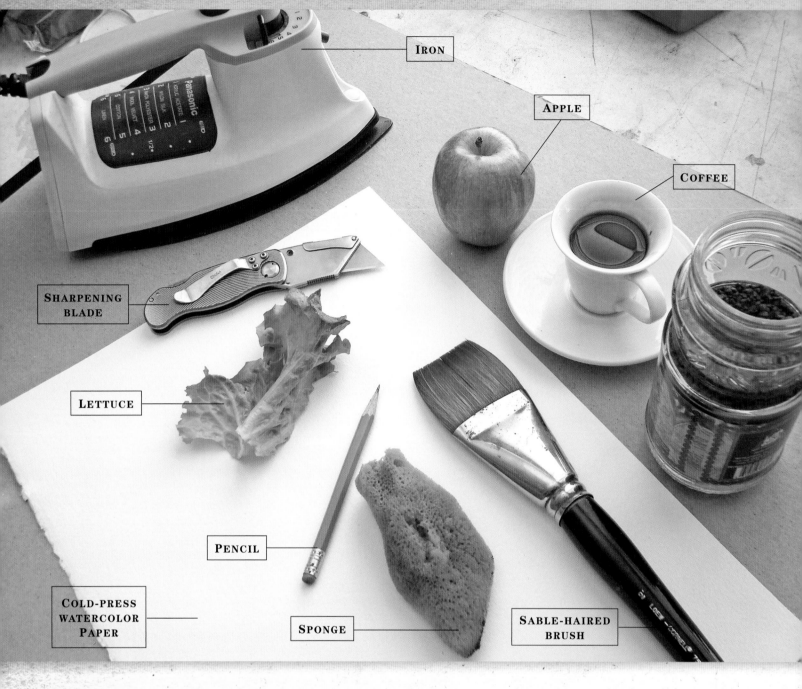

IRON

APPLE

COFFEE

SHARPENING
BLADE

LETTUCE

PENCIL

COLD-PRESS
WATERCOLOR
PAPER

SPONGE

SABLE-HAIRED
BRUSH

# TOOLS OF THE TRADE

Centuries ago, men and women were well-acquainted with various species of dragons and other fantastical creatures, but this knowledge is now the preserve of dragonologists and other specialists. To make your dragon sketches and observations more believable to those outside the dragonology community, you may find it beneficial to age your pieces, adding texture and color, to create the impression that these images are more than a few centuries old.

Whether you are working within the comfort of your own studio or in the field, hidden in abandoned caves, you will want to have several basic materials on hand. A large, flat sable-haired paintbrush works well for washes—soft bristles are best. You may also try using a sea sponge to create a natural texture on your paper. Experiment with a variety of drawing pencils. Crafted to allow a range of effects and tones, the lead hardness of drawing pencils varies. For increased control, I prefer to shorten my pencil

to three-quarters of its original length, using a sharp knife. A knife is also handy for sharpening pencils without wasting lead. Coffee, apples, and lettuce (staples on dragon-hunting expeditions), are all useful for aging your work. When working in your studio, an iron can be useful for flattening the finished piece and preventing warping after the washes of color are applied.

Although you may want to practice these techniques on low-grade paper, you will find that for your finished works, you will achieve the finest results with higher-quality paper. I recommend that you use a fine-grained, cold-pressed watercolor paper similar to the paper that Italian masters used. During the Renaissance, paper was a work of art itself. It was formed out of fine cellulose and the recycled fabric from ship sails and sailors' shirts, which explains its natural yellow tint.

The size of the paper is not important. I have created some of my most important field studies on scraps of newspaper. However, for illustrations that will be used for publication or for the education of future dragonologists, I prefer to use the European 11" x 15" standard size. Of course, masters of the Renaissance such as Leonardo Da Vinci did not adhere to standards of size and were able to create spectacular results.

*During the Renaissance, paper was made from the recycled fabric of ship sails and sailors' shirts.*

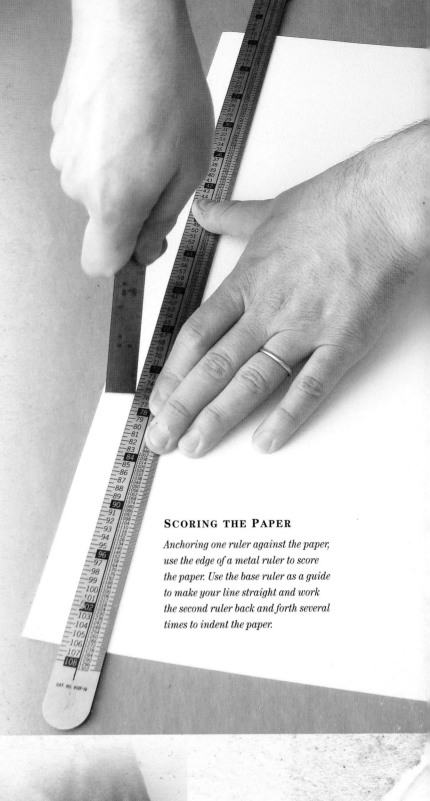

### SCORING THE PAPER

*Anchoring one ruler against the paper, use the edge of a metal ruler to score the paper. Use the base ruler as a guide to make your line straight and work the second ruler back and forth several times to indent the paper.*

### CREATING A DECKLE EDGE

*Pressing down the base ruler with one hand and tearing with the other, create an uneven edge, mirroring the deckle edge of handmade paper.*

# TRAINING YOUR HAND

Like a musician or a champion athlete, master artists must train their hands to hold the pencil correctly, control the pressure of their strokes, and always keep one eye on their subject (however scaly it may be). This is especially important for dragonologists who can become easily distracted by fire, smoke, or the acidic spit of an angry dragon. You must train your hand and eye to remain steady in the face of dangers unimaginable to the uninitiated.

When waiting in caves or near a dragon's lair, practicing your strokes can be a fine way to pass the time. Experiment with a variety of strokes, drawing curvy and straight lines. Relax your body, relax your hand, and relax your eye. However, do not relax your guard! Remain alert to the potential dangers around you. Countless dragonologists have realized an angry dragon was upon them only after they have lost a limb.

After experimenting with different strokes, begin sketching your surroundings while remaining in a relaxed state. Avoid using an eraser, as each of your pencil strokes documents the evolution of your drawing—build up your sketch layer by layer. I find this technique works best with a hard pencil and a soft touch. Using a soft pencil and a hard touch creates dark lines that are difficult to alter.

*Leonardo Da Vinci, **Self-Portrait**, ca. 1512. Red chalk on paper. Courtesy of Dover Publications, Inc. (Image from **Leonardo Da Vinci Treasury**.)*

*Take care to keep one eye trained on your subject at all times, however scaly it may be.*

The thumb, index, and middle fingers of each hand act as a direct extension of the brain and can be trained to exquisitely control the pressure and curve of the lines you draw. Using a free-form style, practice drawing light and dark lines, short and long lines, spirals and infinity signs (a symbol that gives dragons pause, and may provide you with a future getaway).

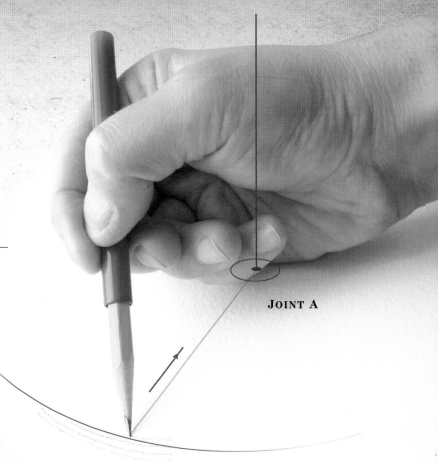

JOINT A

### ANCHORING TECHNIQUE

*Anchor your hand using joints A and B like the pivots on a compass. Use your fingers to guide the pencil arcs, moving from larger to smaller curves. Rest your hand against joint A to create smaller lines, and joint B for larger lines and curves. Use this technique for focused shading.*

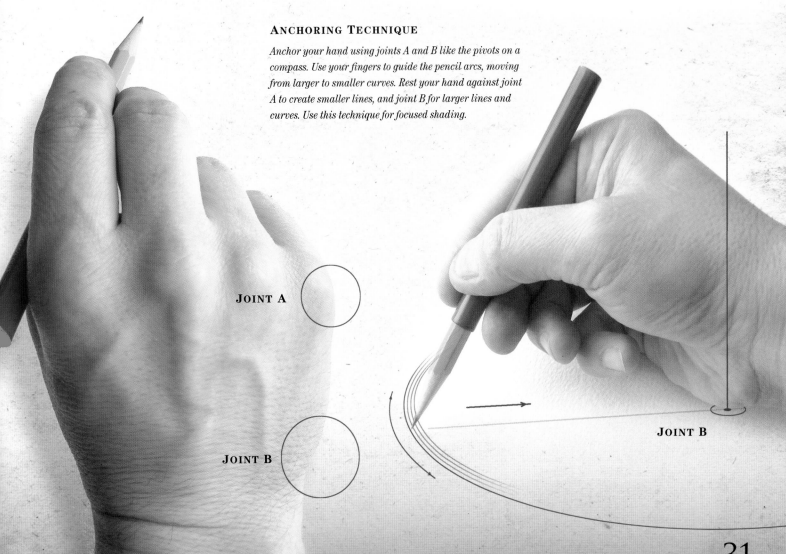

JOINT A

JOINT B

JOINT B

31

# CAPTURING A LIKENESS

I discovered my first Western dragon just a few years ago. Although they are common in literature, their populations are fading as mountains and forests are overtaken by human cities. In the dark alps of Germany, I observed this Western dragon—I believe it was a Black Zephyr—until I was detected and forced to flee. When tracking dragons in the field, it is useful to sketch your subject using a light touch. Build up the lines layer by layer as you become more familiar with the curves and angles of the dragon.

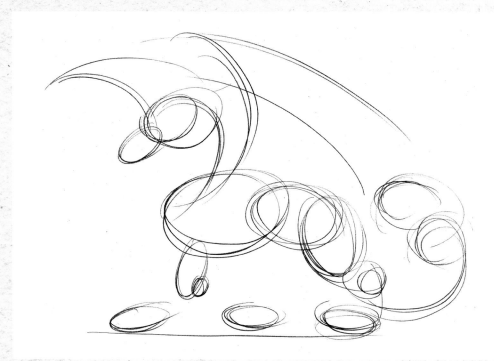

**Step 1** Begin with the softest of curves and lines, barely touching the paper with your pencil. Use basic shapes to reveal the essence of this dragon, marking the body, head, wings, and tail. Imagine the dragon's round forms as bubbles that will slowly develop form and substance. These earliest sketch marks will be visible in the finished piece and act as the base layer for all other details.

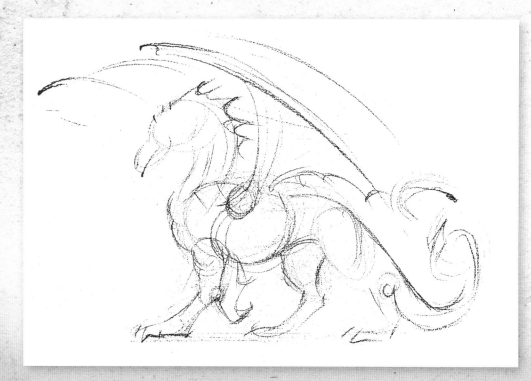

**Step 2** As you become comfortable with your subject, the anatomy will be revealed more precisely. Add darker lines as you identify the joints. You may be reminded of the anatomy of a lion or similar big cat, although they do not share a bloodline with the dragon lineage. Add precise dark points at the tips of the wings, the tip of the horn, and the bottoms of the legs.

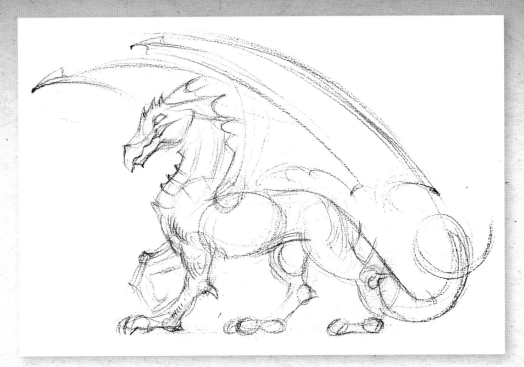

**Step 3** At this stage you'll want to add details such as the eye, emphasize the shadows under each muscle, and develop the impression that this is a 3-dimensional dragon. The legs and tail are bold and full, and the ribcage is prominent.

**Step 4** Using the Da Vinci warrior for reference, add texture to the wings, body, head, and tail. Define the scales along the dragon's tail and chest, and develop the decorative elements of the wings. Add claws and build up the shadows.

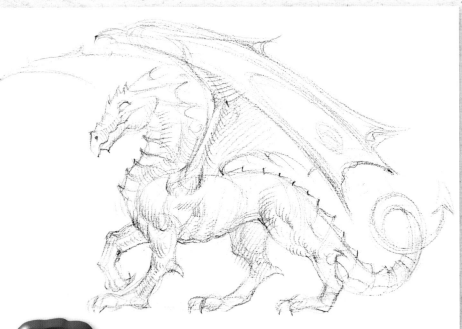

## WESTERN DRAGON

| | |
|---|---|
| **HEIGHT:** | 20 FEET |
| **WINGSPAN:** | 45 FEET |
| **WEIGHT:** | 3 TONS |
| **HABITAT:** | MOUNTAIN OR SEA CAVES IN REMOTE LOCALES THROUGHOUT EUROPE |
| **DIET:** | CATTLE, SHEEP AND (VERY RARELY) HUMANS |
| **POWERS:** | KNOWN TO BE SHAPE CHANGERS AND SPELL CASTERS |
| **SCALE:** | |

20 FEET

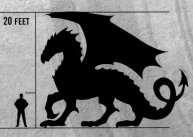

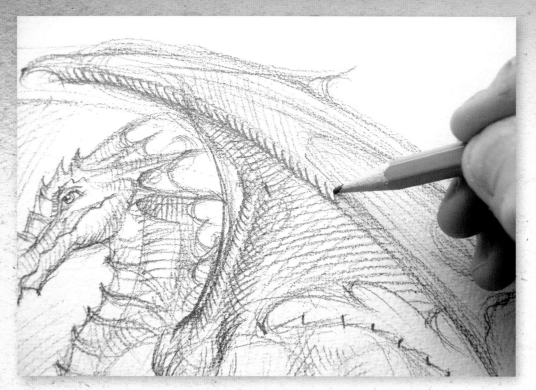

**Step 5** Continue building up the layers of your drawing by adding more texture and shading. Following Da Vinci's lead, create evenly spaced lines and curves using the anchoring technique discussed on page 31, rather than covering whole areas of the paper to shade. Don't overdo this step, as leaving some unfinished areas creates a more balanced and complete composition.

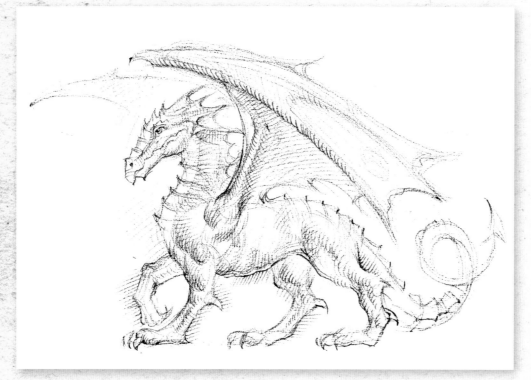

**Step 6** Define the forms of the muscles without concentrating too much on anatomical accuracy. Your eye will naturally place items in their logical position. Make short, quick strokes around the dragon to separate it from the flat page and create a dynamic atmosphere that contributes to the illusion of dimensionality.

**Step 7** Emphasize the outline of prominent body parts, such as the underside of the belly, with darker lines. Be careful to leave a white gap between the outline and your shading strokes to suggest reflected light and convey the roundness of the forms.

*Let yourself indulge in close study of your subject and complement your drawing with sketches of anatomical details or quick field notes.*

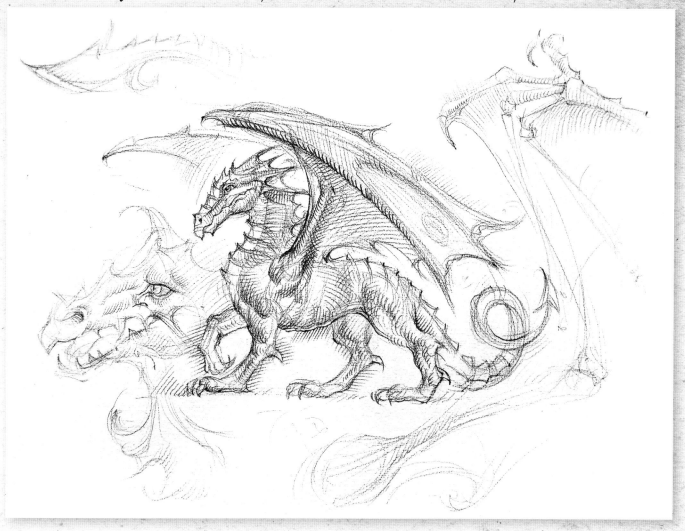

**Step 8** Da Vinci often included small sketches documenting spontaneous bursts of creative ideas in his larger drawings. In observing the dragon, you may find yourself drawn to specific body parts or behavioral patterns. Let yourself indulge in close study of your subject and complement your drawing with sketches of anatomical details or quick field notes.

# AGING THE PAPER

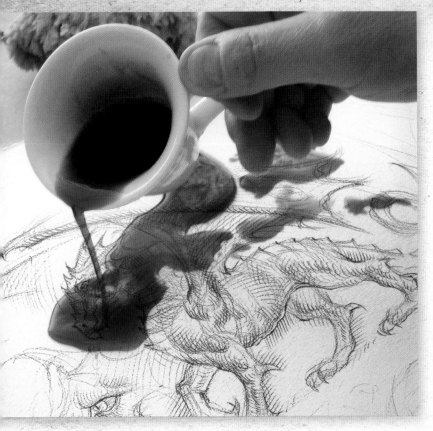

To avoid questions and criticism from those who doubt the existence of dragons, you may find it useful to age your paper so it appears to be a 500-year-old artifact. I find that a coffee wash works well. I prefer instant coffee, as it is something I often have with me on my expeditions. You may also want to experiment with tea or burnt sienna watercolor paint.

Begin by using a sea sponge to dampen the paper with a light wash of plain water. Work slowly and gently dab with the sponge to avoid damaging your paper. This works to remove the layer of oil often found on watercolor papers. Let your paper dry as you work on your Drako language skills. The dry paper will accept the coffee wash more easily.

Use a large soft, flat brush to lay down the wash. Begin with horizontal strokes and then work vertically. The color does not need to be even to add the desired effect. Some places will have more water and some will have more color. Don't overdo it. One to three layers of color work well. After applying the color, hold the paper vertically and let some of the coffee stream down. Change direction to move the pigmented water and create a nice marbleized effect.

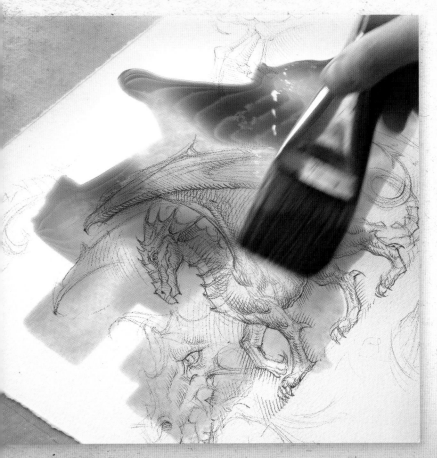

*I prefer to use instant coffee, as it is something I often have with me on my expeditions.*

## DRAGON COURTSHIP RITUALS

*Similar to birds, dragons sail through a series of elaborate moves to court dragonesses. During the spring, males migrate in search of females and challenge their rivals to fatal duels to demonstrate their physical prowess. Complex, graceful flight patterns and intricate serpentine dances are performed to attract a dragoness' attention. Male dragons have also been known to lay food offerings at the entrance of a female's lair to gain her favor.*

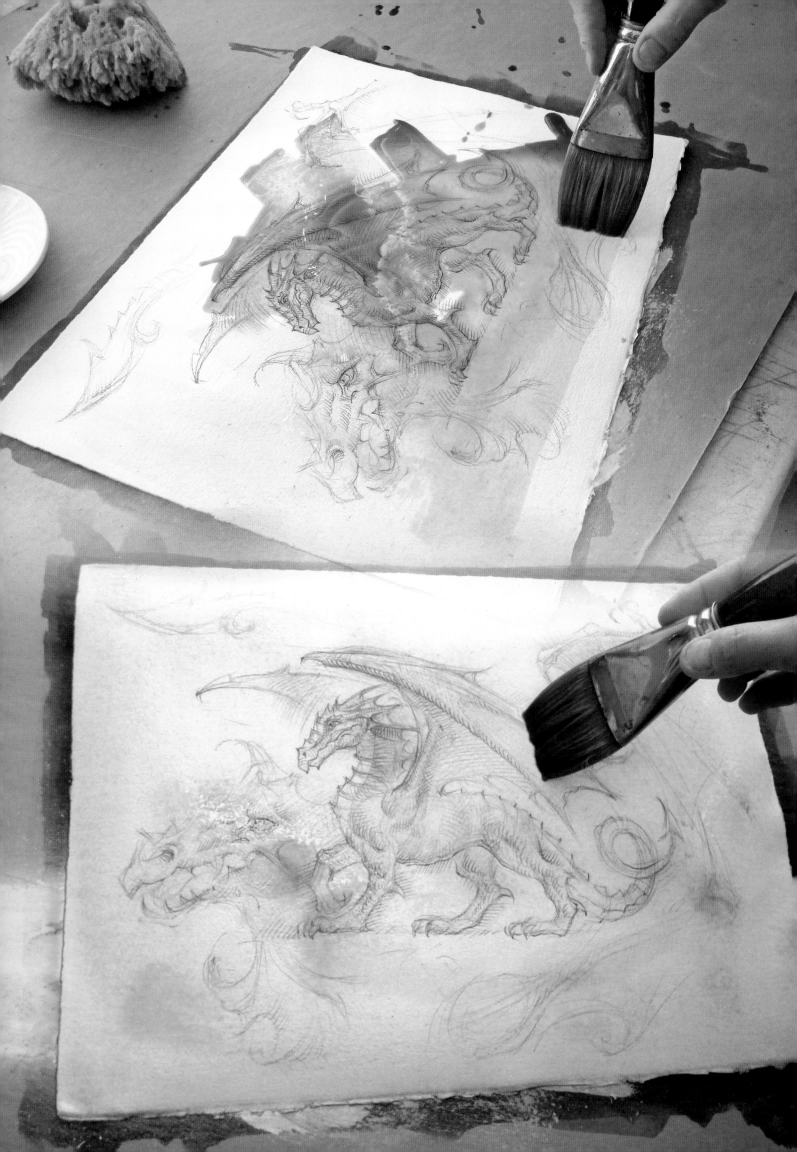

# TRANSFORMING THE PAPER

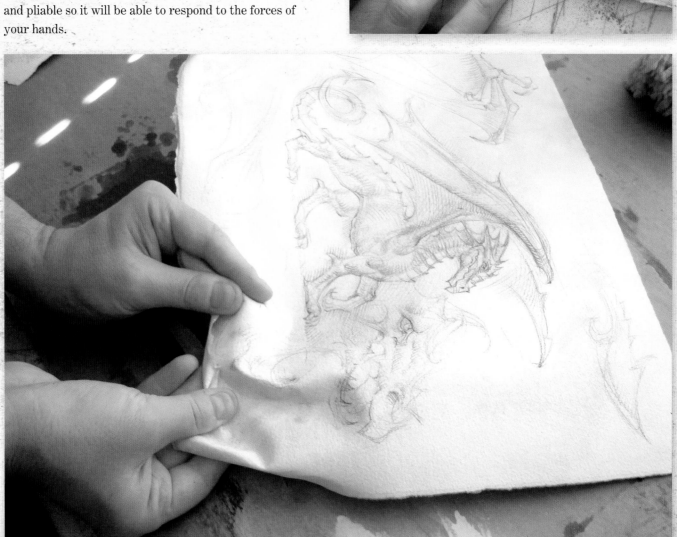

A fellow dragonologist recommended manipulating the edge of the paper to add to the aged appearance of the illustration. Adding wrinkles and other textures to the surface of the paper is also great for establishing authenticity.

**Step 1** Work the edges of the paper while it is still wet and pliable so it will be able to respond to the forces of your hands.

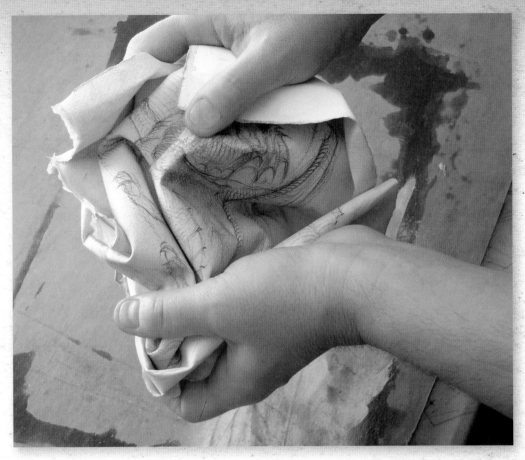

**Step 2** Gently crush and smash the paper in your hands. Practice on a spare piece of paper before working on your finished piece. Be careful not to create so many creases that you distort the image. You can tear the paper slightly on one side.

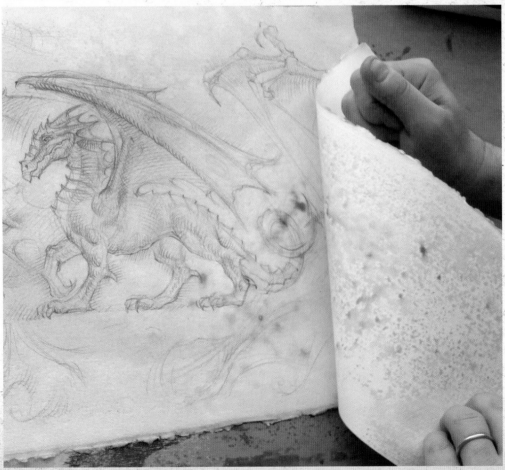

**Step 3** Finish by firmly pressing a dry piece of paper against the wet paper and then immediately pulling it off. This will create the appearance of paper that has begun to decompose from the effects of mold, light, and acid.

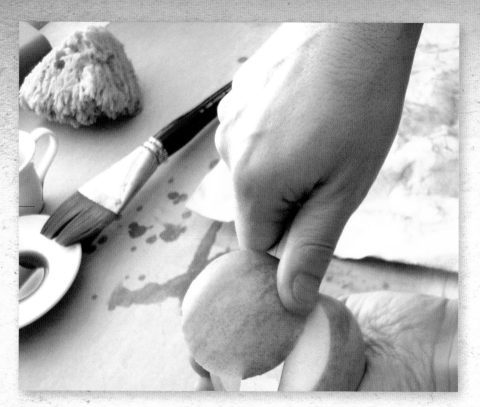

**Step 4** Cut off a slice of apple and rub it against some parts of the drawing, especially areas that contain few or no pencil strokes. The acids will seep into the creases and contribute to the worn, aged appearance of the paper.

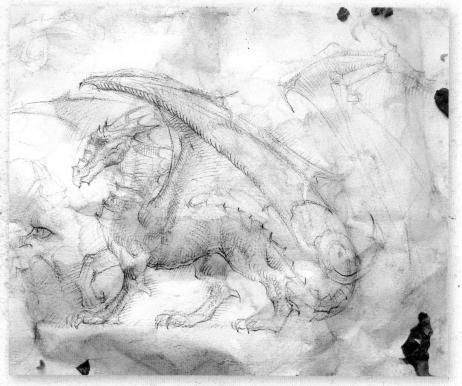

**Step 5** Next add a moldy look to the creases with chlorophyll from the leaves of a green vegetable, like lettuce. Rub the lettuce leaf gently and unevenly over the paper. Apply these touches sparingly, as you don't want to create a pattern. The signs of aging should appear as natural as possible.

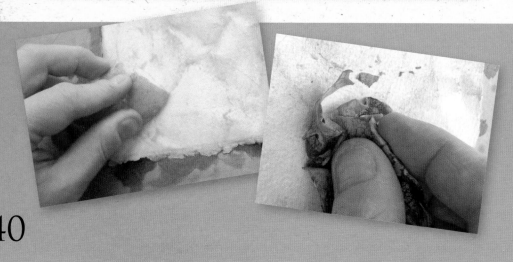

## UNLIKELY TOOLS

*The contents of your refrigerator can yield useful tools for creating texture. Experiment with different fruits, vegetables, or dairy products, but avoid fatty foods that leave a greasy residue. I prefer using apples, as the fruit's acids produce a wonderful effect.*

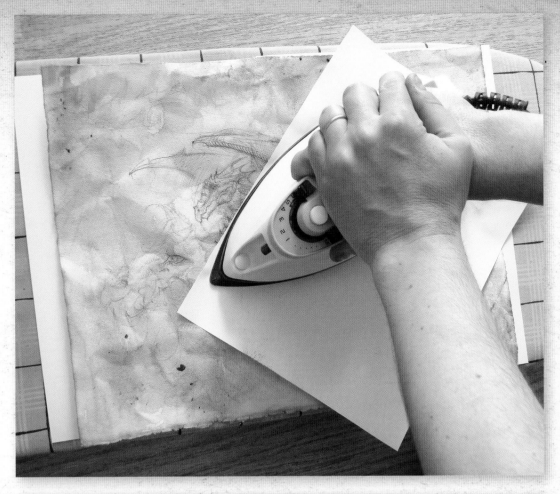

**Step 6** Once you have achieved the desired results, you will need to re-flatten your drawing with a warm iron. Turn the iron to the lowest setting and place a sheet of paper over the drawing to protect it from the heat. However, be sure to turn off and unplug the iron after use and keep the hot iron away from children.

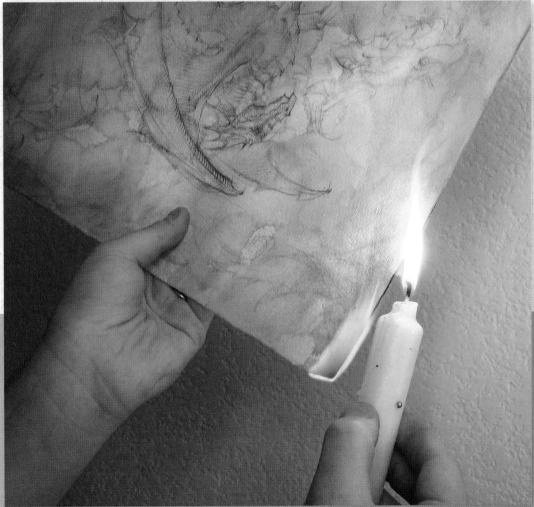

**Step 7** You may also want to burn the edges of the drawing with a candle or lighter to indicate the fire damage common in books and artwork from the Renaissance period. Hold the flame to the edge of the paper for just a few seconds before blowing it out, and make sure there are no flammable objects nearby.

# DA VINCI, RENAISSANCE MAN

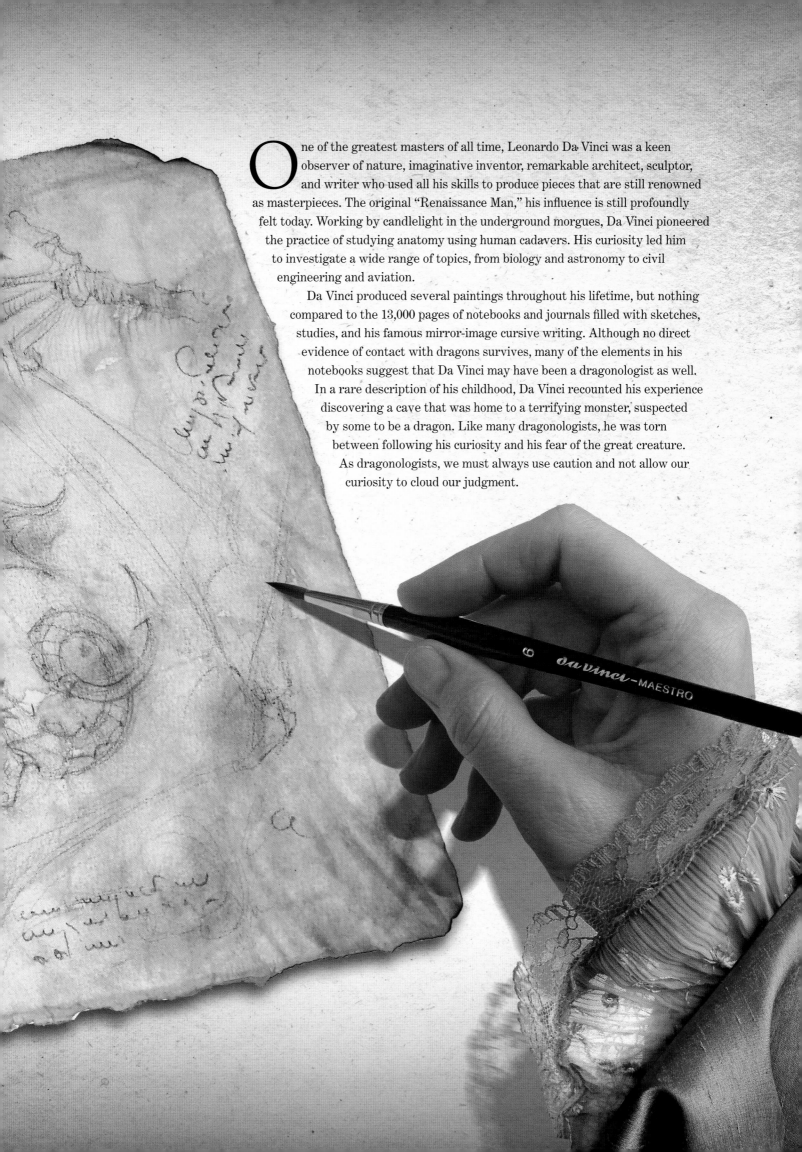

One of the greatest masters of all time, Leonardo Da Vinci was a keen observer of nature, imaginative inventor, remarkable architect, sculptor, and writer who used all his skills to produce pieces that are still renowned as masterpieces. The original "Renaissance Man," his influence is still profoundly felt today. Working by candlelight in the underground morgues, Da Vinci pioneered the practice of studying anatomy using human cadavers. His curiosity led him to investigate a wide range of topics, from biology and astronomy to civil engineering and aviation.

Da Vinci produced several paintings throughout his lifetime, but nothing compared to the 13,000 pages of notebooks and journals filled with sketches, studies, and his famous mirror-image cursive writing. Although no direct evidence of contact with dragons survives, many of the elements in his notebooks suggest that Da Vinci may have been a dragonologist as well. In a rare description of his childhood, Da Vinci recounted his experience discovering a cave that was home to a terrifying monster, suspected by some to be a dragon. Like many dragonologists, he was torn between following his curiosity and his fear of the great creature. As dragonologists, we must always use caution and not allow our curiosity to cloud our judgment.

# STUDYING RUBENS' STYLE

Fusing the techniques that he learned from the masters of the Italian Renaissance with the Flemish painting tradition, Peter Paul Rubens (1577–1640) transformed oil painting into an innovative medium. Typically Rubens began by creating a sketch of his subject. Then his assistants transferred the sketch to a canvas, sizing the image to be larger than life. Rubens would then tone the canvas with layers of brown paint. Using the *sfumato* technique developed by Da Vinci, Rubens created his distinct style by layering paint to create the impression of light being revealed from a shadowed and muddy background. This technique is especially useful for portraying dragons in dimly lit caves.

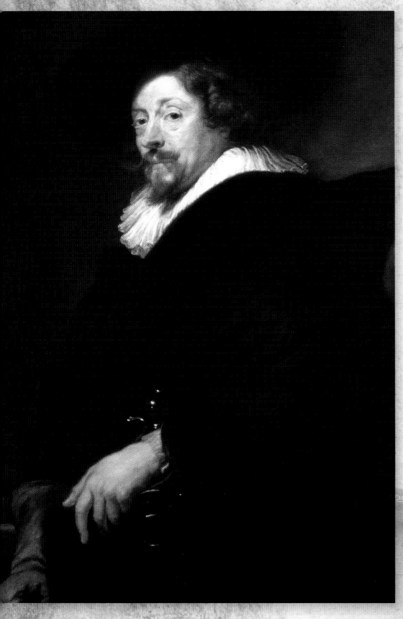

*Peter Paul Rubens, **Self-Portrait**, ca. 1638–1640. Oil on canvas. Photo © Francis G. Mayer/Corbis.*

A collection of oil paints is often useful when depicting dragons and their lairs. Oil paints are a versatile medium that is ideal for free, rapid work in the field, as well as more finished works in the studio. You can experiment with using small canvases to create dragon studies in the field. In your studio, you may find that a 16" x 20" artist-grade canvas works well for dragon portraits that commemorate their subjects. When working in the Rubens style, you'll need a good variety of brown paints that reflect the earthy tones of his palette and the dark crevices of dragon hideaways.

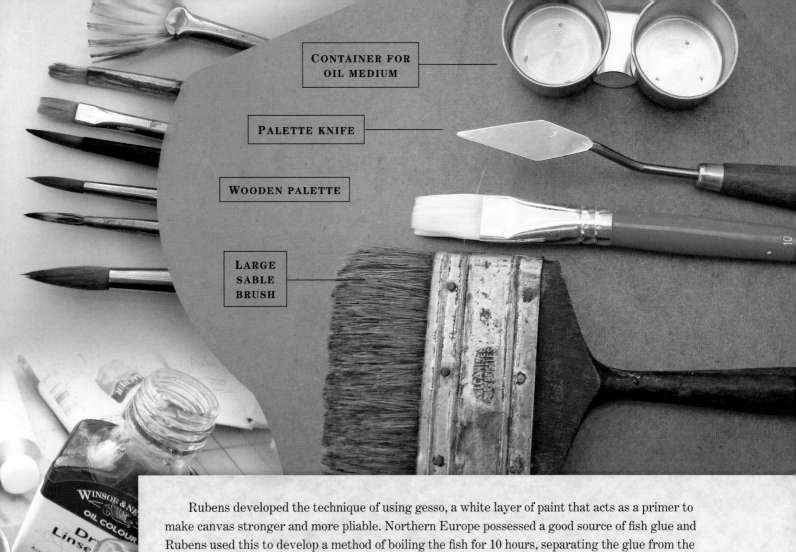

CONTAINER FOR
OIL MEDIUM

PALETTE KNIFE

WOODEN PALETTE

LARGE
SABLE
BRUSH

Rubens developed the technique of using gesso, a white layer of paint that acts as a primer to make canvas stronger and more pliable. Northern Europe possessed a good source of fish glue and Rubens used this to develop a method of boiling the fish for 10 hours, separating the glue from the bones, and mixing it with white chalk, pigment, and oils to create gesso. Today, you can purchase gesso at your local art store instead of boiling fish for many hours, and an assortment of pre-primed canvases are available if you have never worked with gesso before. However, I suggest that you create your own oil medium from equal parts drying linseed oil, bleached linseed oil, and liquine. Pour this mixture into a small metal container, and the different elements will work together to thicken your paints and help them dry faster.

A palette knife is useful for transferring paint from the tube to the palette and it can be used for applying large amounts of paint to the canvas. However, do not rely on this knife when faced with an angry dragon—you will need a much larger knife to defend yourself! When working with oil paints, I prefer a thin, wooden palette, like the palettes master artists used. To capture the wide range of dragon shapes and textures, I use a variety of brushes, including several different sizes of round and flat brushes, and a fan-shaped brush. The large sable-haired brush shown in the photograph is one of my favorite brushes, passed down to me from my father in Russia. A wide brush like this one works well for blending the base layer of paint onto the canvas.

## PRIMING YOUR OWN CANVAS

*It's economical and easy to prime your own supports. Gesso—a polymer product with the same base ingredients as acrylic paint—is a great coating material because it primes and seals at once. It's also fast-drying and is available at any art supply store. Use a standard 1/8" pressed-wood panel from the lumber store, and sandpaper its surface until the shine is gone. Then apply two or three coats of gesso, sanding the surface in between coats and using both horizontal and vertical strokes for even coverage and texture.*

# WORKING WITH OIL PAINT

The Rubens style requires an understanding of oil techniques and respect for the time involved with this medium. You'll want to begin by tinting your canvas. This is an easy task that can be accomplished while you are on a stake-out or when you have returned to the studio, exhausted after a long expedition and still recovering your senses.

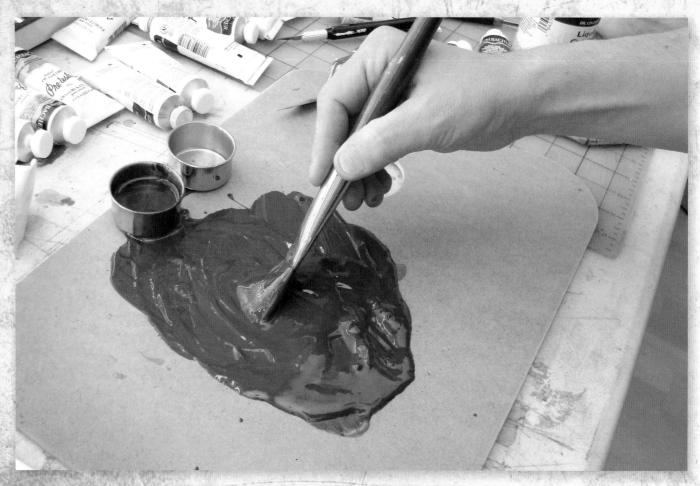

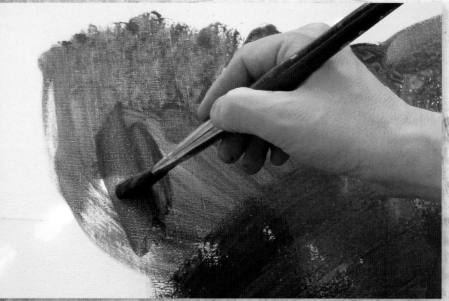

**Step 1** Begin by mixing a large amount of the base color that will be used to tint the canvas. Use yellow ochre, burnt sienna, and burnt umber to create a rich brown color. Using a #8 brush, apply a thin glaze of oil paint mixed with oil medium. The base coat can be worked in an easy style; uneven patches will add texture to the background.

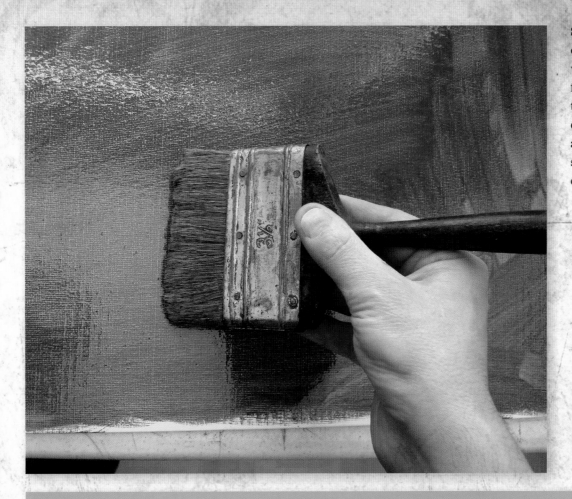

**Step 2** Once you have covered the canvas with paint, use a large, flat brush to distribute the paint into the canvas with horizontal and then vertical strokes. Let this base coat dry for 24 hours.

## OIL TECHNIQUES OF THE MASTERS

*The variety of effects you can achieve—depending on your brush selections and your paint application techniques—is virtually limitless. A few of the masters' favorite approaches to oil painting and brushwork techniques, such as blending and glazing, are outlined below. You may also want to try more modern techniques, such as painting thickly and stippling. Just keep experimenting to find out what works best for you.*

### PAINTING THICKLY

*Load your knife with thick, opaque paint and apply it liberally to create texture.*

### DRYBRUSH

*Load a brush, wipe off excess paint, and lightly drag it over the surface to make irregular effects.*

### GLAZING

*Apply a thin layer of transparent color over a dry color. Let dry before applying another layer.*

### THIN PAINT

*Dilute your color with thinner and use soft, even strokes to make transparent layers.*

### BLENDING

*Use a clean, dry hake or fan brush to lightly stroke over wet colors to make soft, gradual blends.*

### STIPPLING

*Using the tip of a brush or knife, apply thick paint in irregular masses of small dots to build color.*

# CAPTURING A LIKENESS

While your canvas dries, you can work on creating a sketch that will guide you as you paint. If you are creating a portrait of a dragon that you observed in the wild, you may already have a sketch on hand, but it is always useful to study the composition of your sketch. Make sure your image is balanced and dynamic, with lines that lead the viewer's eye through the picture plane. Use a piece of paper the same size as your canvas to judge your subject placement.

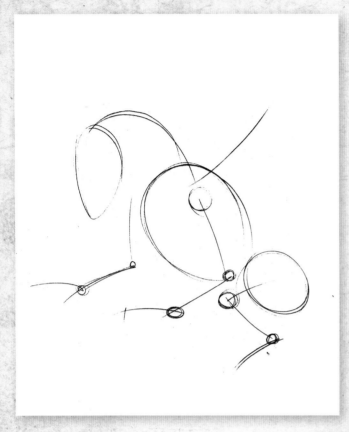

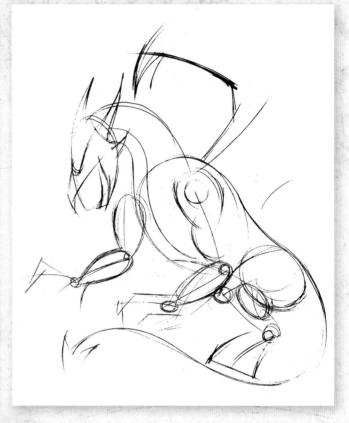

**Step 1** Using a loose hand, identify the main elements of the dragon. Draw in the round central rib cage, the curved spinal cord, and massive muscles on the rear legs. Note that the head of the dragon is slightly smaller than the rib cage. Add circles to identify the joints and anchor the dragon to the page.

**Step 2** Develop the edges of the dragon. Identify the shape of the wings. When depicting dragon anatomy, you may find it helpful to sketch horses and lions that can be observed more safely. Follow Rubens' lead by taking time to find the curves of your subject and emphasize the musculature. (See pages 20–25 for more on dragon anatomy.)

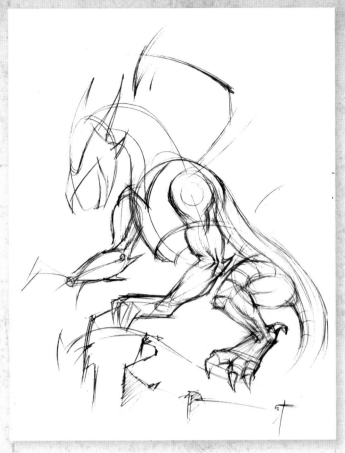

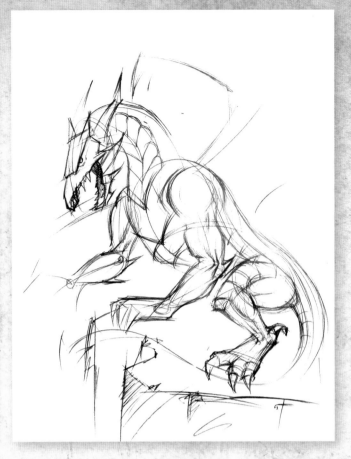

**Step 3** Develop details such as the fingers, claws, and tail. As you sketch you will draw many light, overlapping lines. When you see the line you like and it is settled in just the right place, draw firm lines with a sharp, soft pencil to determine the final shape of the dragon. Add the rocky ledge that the dragon is sitting on.

**Step 4** Define the horns, teeth, scales, and neck. Start adding shadows to the muscles to add dimension to the body. Don't spend too much time on one particular area. Keep moving your hand to keep your eye and mind fresh.

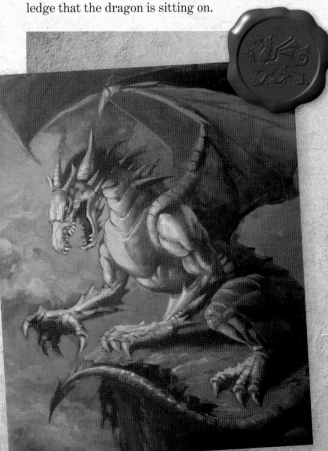

## STORM DRAGON

| | |
|---|---|
| **HEIGHT:** | 35 FEET |
| **WINGSPAN:** | 80 FEET |
| **WEIGHT:** | 12,000 POUNDS |
| **HABITAT:** | THE APPALACHIAN HIGHLANDS OF EASTERN NORTH AMERICA |
| **DIET:** | GRAY WOLVES, CARIBOU, AND BLACK BEARS |
| **POWERS:** | ABILITY TO CONTROL THE WEATHER WITHIN A RADIUS OF 5 MILES, CAN WITHSTAND EXTREME TEMPERATURES, FLIGHT |
| **SCALE:** | |

35 FEET

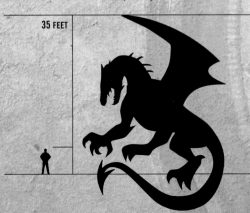

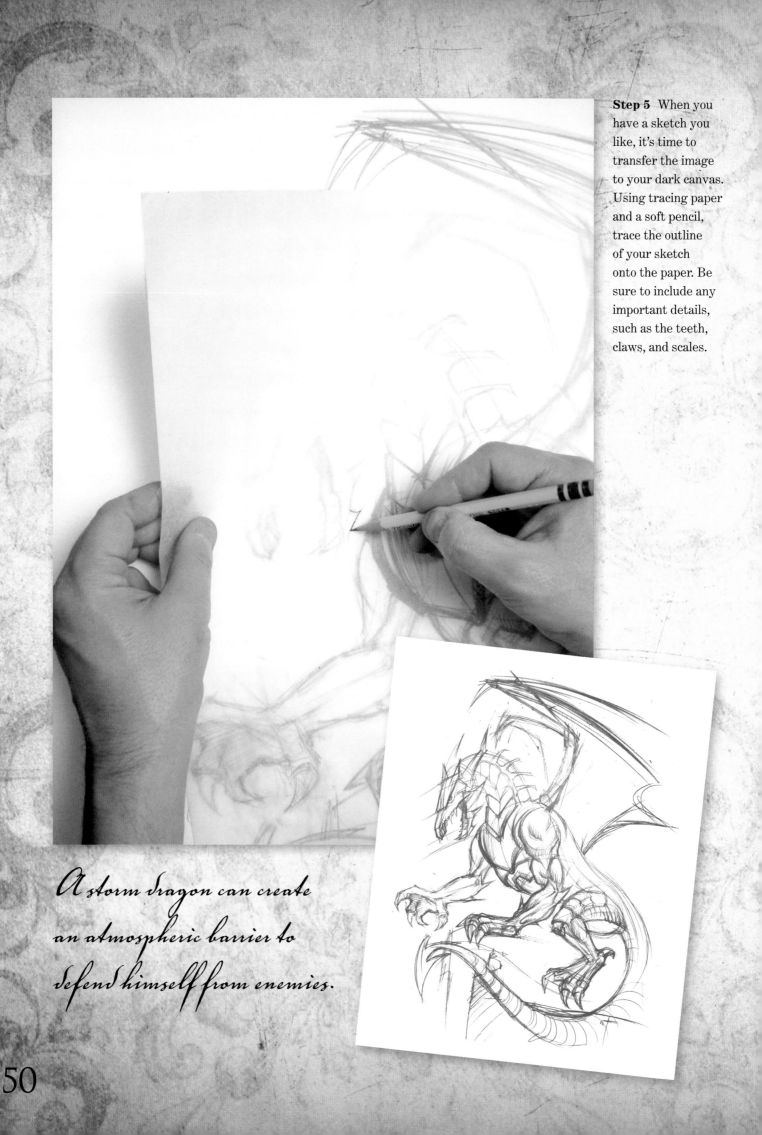

*A storm dragon can create an atmospheric barrier to defend himself from enemies.*

**Step 6** Flip the tracing paper over and use a white conte pencil or pastel to trace everything you see through the paper. Turn the paper over one more time and tape it onto the canvas. Use a drawing pencil to trace over the image. This will transfer the white impression onto your dry canvas. You can use the white outline as a guide throughout the painting process.

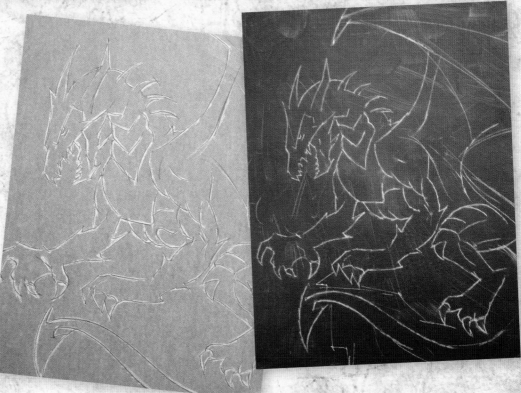

## DRAGON MAGIC

*As dragons mature, they develop more potent skills. Very old dragons are capable of transforming themselves into animals of equal or lesser size for a limited period of time. However, ancient wyrms can shapeshift into human beings and remain in this form for years. Several trusted advisors to famous rulers are purported to have been dragons in the guise of humans.*

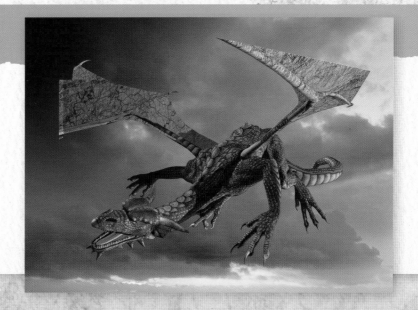

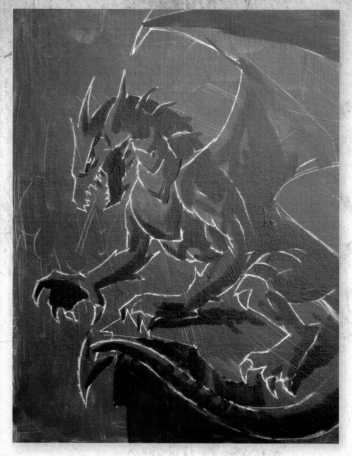

**Step 7** Following Rubens' lead, begin by painting the darkest shadows. Using a mixture of burnt umber with a small amount of oil medium, apply solid, dark shadows with a dry #6 brush. The light is coming from the top left corner, so the shadows should be positioned at the bottom right side of each shape. The dry brush will allow you to build up dark tones evenly and slowly, layer by layer.

**Step 8** Add shadows to the right sides of the head, scales, wings, tail, and claws. Use the oil medium to blend the shadows into the background. If your mixture is the consistency of jelly, or even dragon blood, you need more paint.

**Step 9** Add highlights with a mix of naples yellow, yellow ochre, and a hint of titanium white. With a dry brush, identify the light areas at the top left side of the canvas. Painting in this burst of light will help to define the outline of the dragon. Avoid making the highlights too uniform. Uneven color creates a more vibrant and realistic look. Let the highlights and shadows dry thoroughly.

*The light source in a typical Rubens painting comes from the top left corner of the picture plane.*

# KOMODO DRAGON

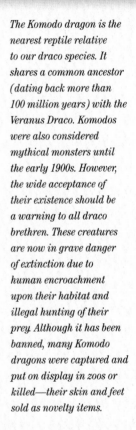

The Komodo dragon is the nearest reptile relative to our draco species. It shares a common ancestor (dating back more than 100 million years) with the Veranus Draco. Komodos were also considered mythical monsters until the early 1900s. However, the wide acceptance of their existence should be a warning to all draco brethren. These creatures are now in grave danger of extinction due to human encroachment upon their habitat and illegal hunting of their prey. Although it has been banned, many Komodo dragons were captured and put on display in zoos or killed—their skin and feet sold as novelty items.

## CONSERVATION ACTIONS

*You, noble dragonologist, have the power to protect dragons! Learn as much as you can regarding dragon habitats, diet, and behaviors to increase your awareness of and ability to oppose factors that threaten dragon survival. And your most important duty is to guard this knowledge at all costs!*

### MIXING COLORS

*I find that colors look best when I mix no more than three together at once. This helps avoid muddiness. It is always best to experiment with creating a color palette before working directly on the canvas.*

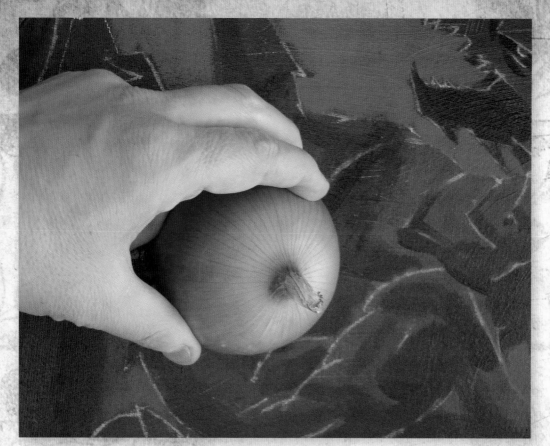

**Step 10** After your canvas has dried, you'll want to treat your painting so that the next layer of paint will connect well to the previous layer. Cutting an onion in half and gently rubbing it onto the painting is an ancient technique that has been passed down from artist to artist for centuries. The chemicals in the onion will blend the oils in each layer of paint.

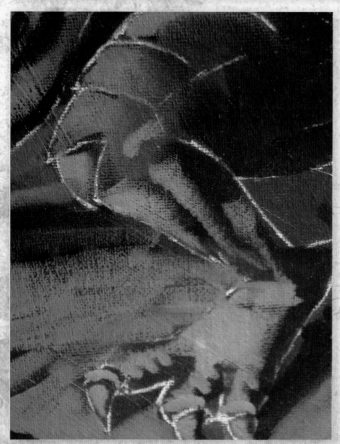

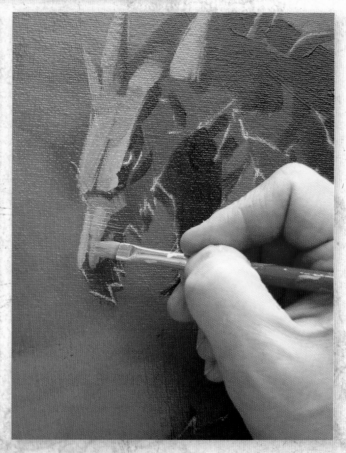

**Step 11** Adding warm and cold highlights was Rubens' forte. The right highlights can make a painting come alive. Create a mixture of naples yellow, cerulean blue, and a hint of orange to create a tone that is almost neutral. Use a dry, flat #3 brush to layer the paint and add dimension to the dragon. For the head, use a bit of green and emphasize the forehead.

**Step 12** The highlights for each part of the body should have a different mixture. Add a different color to the naples yellow and cerulean blue pairing. Add a bit of orange to the neck and chest, which is shinier and reflects the sunset. Small variations within the earthy palette will add visual interest and realism to your dragon portrait.

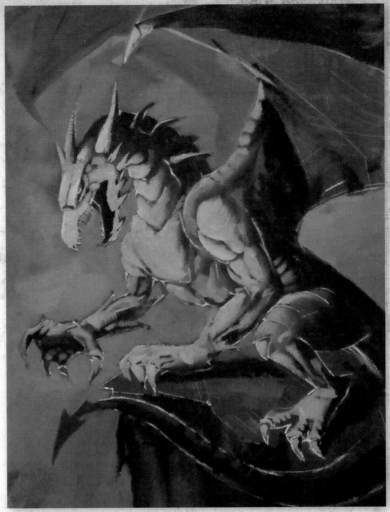

**Step 13** The biceps have a colder tint, so add a bit of violet to the mixture. Let the white pastel outline continue to guide you. Use a brown glaze with a heavy dose of oil to blend the highlights. Use your best judgment to adjust the tone to keep the feel of the painting true to the nature of the dragon and your observations.

**Step 14** Add highlights to the arms, back legs, and muscles. Emphasize the top edges of the claws. You may find it helpful to reference your sketch for details like the horns, spikes, eyes, and claws. Add a small amount of blue and violet to the edges of the sky, and use a large brush to build up the clouds. Rubens would add multiple glazes of color, but we do not have the luxury of time when capturing the images of the remaining dragons of the world. Simply let your canvas dry overnight before beginning the final stage.

*Treating the layers of a painting with an onion is a technique that has been passed down from artist to artist for centuries.*

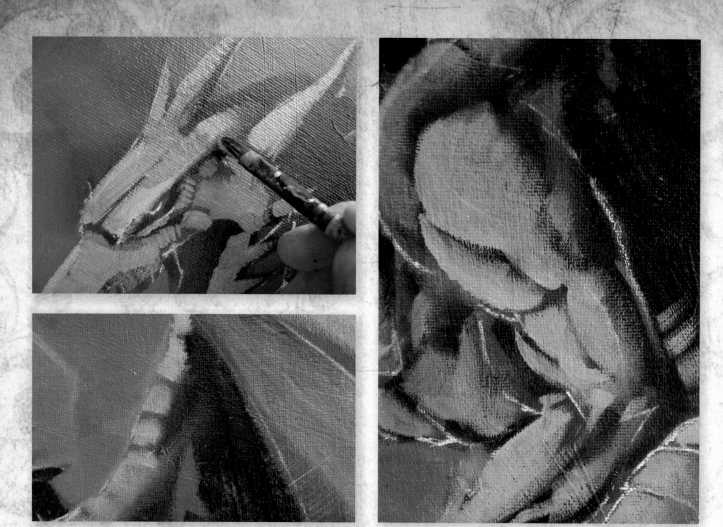

**Step 15** The final stages of the painting are when the image comes alive. Here you will add more details and highlights, using the brush to sculpt the light. Feel the weight of the brush in your hand as you trace the shape of the dragon's body and head. Imagine your hand is actually following the three-dimensional forms of the dragon's muscles as you paint to guide your movements and create the illusion of depth. Vary your strokes, making some firm and some soft.

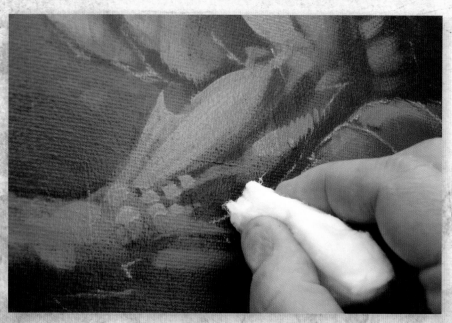

This is a strong, old dragon that is not easily irritated, but will retaliate quickly when angered.

**Step 16** Start removing the white pastel strokes with a cotton ball and water. Be careful to not press too hard.

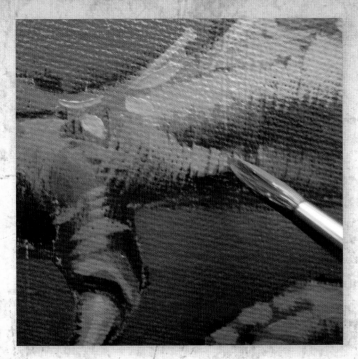

**Step 17** Use a very small brush to create round, concentric strokes similar to the strokes you used with the Da Vinci sketches. It can be helpful to trim the brush into a point so it leaves a sharp point at the end of the stroke. Then add the fierce dragon's fiery red eye.

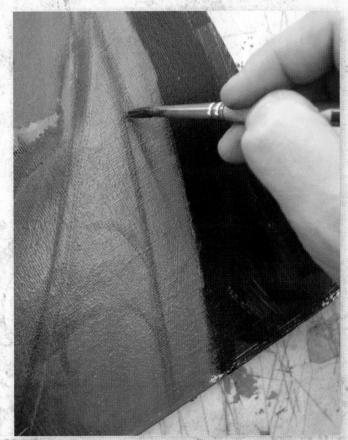

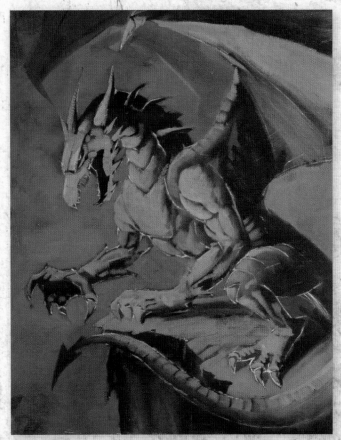

**Step 18** Add details on the wings. This dragon's wings are semi-transparent so you will be able to see some light shining through. The blood vessels and reflection from the sunset also contribute to the transparency of the wings.

**Step 19** As you develop the muscles and various parts of the dragon, pay special attention to the dragon's skin, which is similar to an elephant's tough hide. Be careful to not use too much white so the color does not become too washed out or shiny.

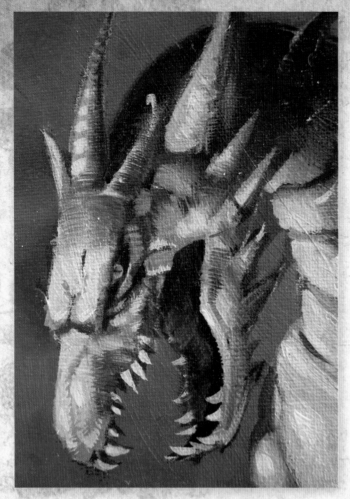

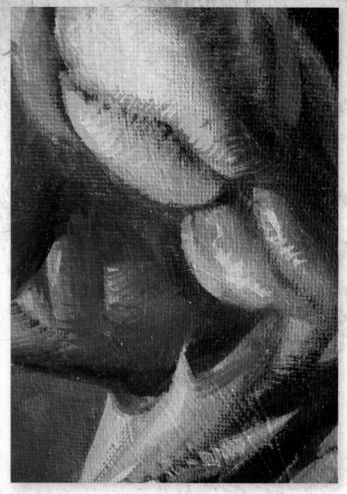

**Step 20** Work in the shadows of the face, neck, and abdomen. The space where the light and shadows meet should be darkest. Add a dark glaze of burnt umber to emphasize these areas.

**Step 21** Further define the muscles and give them more volume by accentuating their shadows. These final touches honor the true nature of the dragon. This is a strong, old dragon that is not easily irritated, but he will retaliate quickly when angered. Your portrait of him displays this personality well.

**Step 22** Add additional highlights by choosing lighter tones of the colors that you used earlier for each area. If you used green in the head before, now add highlights of green mixed with a bit of titanium white. If you added orange highlights to the chest, layer on lighter orange highlights.

**Step 23**
Enrich the dark tones of the background by working in black and burnt umber. Use a fan brush to lift up some paint and blend the background.

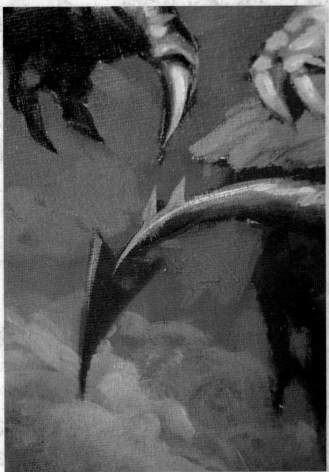

**Step 24** Remember to capture the dragon's environment, establishing the clouds and the reflection of the setting sun. Take breaks, stopping to reflect on your work and relax your eyes. Come back to the painting every so often to decide if it is finished.

**Step 25** The final element is to add a few cold tone reflections in the dragon's features like the arms, legs, and at the bottom of the horns. Mix ultramarine blue, a small hint of white, and a small amount of brown umber, and use very tiny, directed brush strokes to draw out the colder spots. Use a coat of the oil varnish to add luster in select spots such as where the shadow of the dragon's body meets the rock.

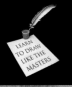

*Peter Paul Rubens*

# RUBENS, MASTER OF LIGHT AND FORM

*Peter Paul Rubens, **The Kidnapping of Ganymede**, 17th century. Oil on canvas. Photo © The Gallery Collection/Corbis.*

Recognized throughout Europe as a master artist during the Baroque era, Peter Paul Rubens produced thousands of paintings over the course of his life from 1577 to 1640. His use of glazing and technique of working from shadows to highlights created an effect of lifelike transparency and luminosity. The forms and flesh of his subjects are solid, sensual, and very dimensional. Rubens thoroughly enjoyed life and that is reflected in the vibrant colors and tonal harmonies of his paintings.

Often commissioned by royalty and other wealthy patrons, Rubens traveled on his clients' behalf diplomatically to a wide variety of countries. He is commonly thought to be fluent in five languages, but perhaps knew a touch of Drako as well.

Rubens created hundreds of paintings of scenes from the Bible and Ancient Greek legends. He depicted a number of animals, even the winged horse Pegasus. Although very few of Rubens' paintings featuring dragons survived, some have suggested that his painting of Saint George and the Dragon is evidence that Rubens took an active interest in dragonology.

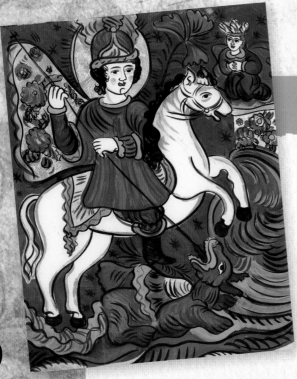

## SAINT GEORGE AND THE DRAGON

In the 3rd century a fearsome dragon was ravaging the town of Silene and made its lair in a swamp. The dragon required human sacrifices every week and just when the local princess was next in line, Saint George arrived on horseback. One of the most famous dragon slayers throughout all of history, George slew the dragon with his sword Ascalon and saved the princess. After this slaying, dragons came to call humans "georges." This story became the subject of many works of art, including Rubens' painting, Saint George and the Dragon, in the early 1600s. In England, April 23rd is Saint George's day and he serves as the patron saint of dozens of countries.

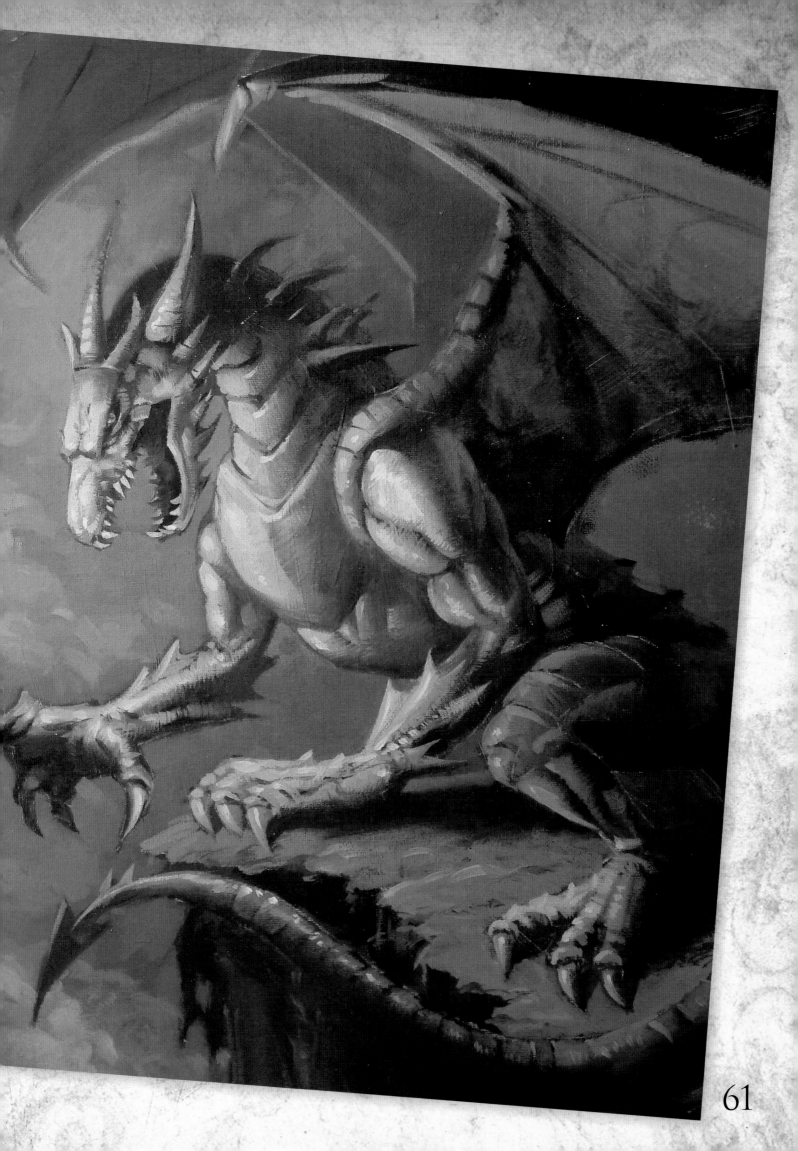

# STUDYING VAN GOGH'S STYLE

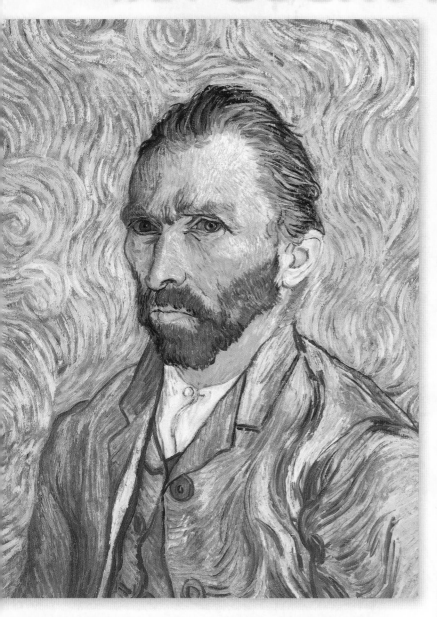

The eldest child of a Dutch pastor, Vincent Van Gogh (1853–1890) tried his hand and failed at many careers before becoming an artist, including an apprenticeship with an international art dealer, teaching, bookselling, and preaching. While serving as a clergyman in a coal-mining district in Belgium, Van Gogh was deeply moved by the miners and their families. He began drawing these peasants while living amongst them in poverty, causing his dismissal from the church in 1880. Inspired by his longtime interest in art and excited by his charcoal drawings of the peasant class, Van Gogh decided to follow his passions and become an artist. With the financial support of his brother Theo, he threw himself wholeheartedly into creating art.

Van Gogh's paintings are widely recognized by people of all ages, and he is known for developing a bold style of painting that inspired expressionists of the following century. Van Gogh's early works feature working-class

*Vincent Van Gogh, **Self-Portrait**, 1889. Oil on canvas. Courtesy of Dover Publications, Inc. (Image from **120 Portrait Paintings**.)*

## COLOR AND MOVEMENT

*Rather than limiting his palette to local color, or the true color of objects, and reproducing the textures he observed, Van Gogh used colors and brushstrokes to create contrast and express mood. Notice how the oranges in his hair and flesh stand out against the bluish background in the self-portrait above. The viewer's attention is drawn to the shadowed area around the artist's furrowed brow and intense eyes, as these green-blue colors are echoed in the curving folds of his suit and the energetic swirls of the background.*

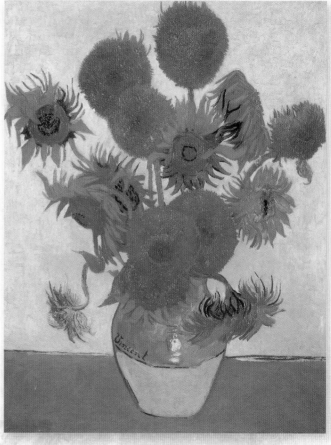

*Vincent Van Gogh, **Sunflowers**, 1888. Oil on canvas. Courtesy of Dover Publications, Inc. (Image from **120 Great Impressionist Paintings**.)*

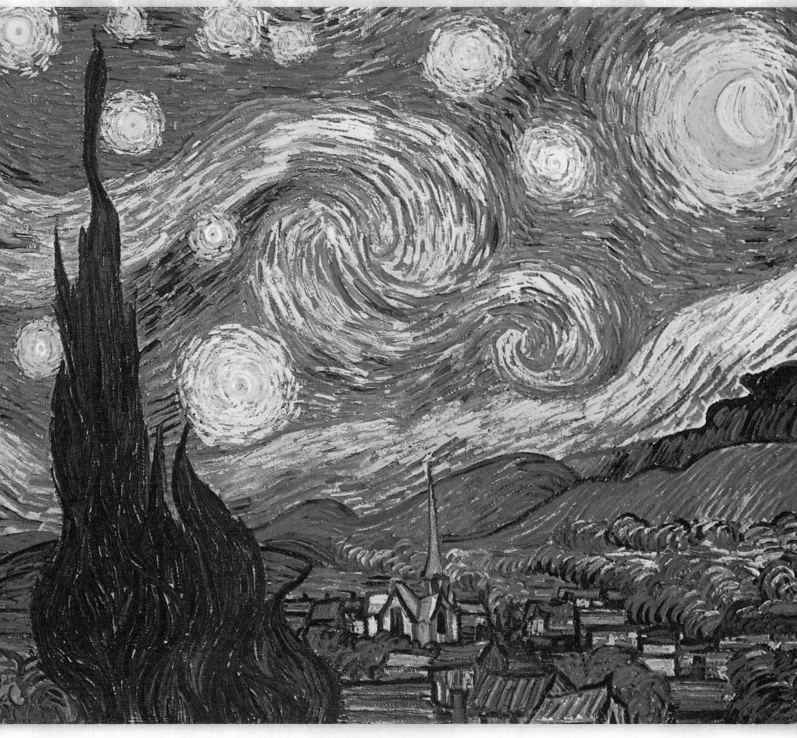

*Vincent Van Gogh, **Starry Night**, 1889. Oil on canvas. Courtesy of Dover Publications, Inc. (Image from **120 Great Impressionist Paintings**.)*

subjects, dark colors, and heavy forms. A self-taught artist with an excellent grasp of color, composition, and portraiture, Van Gogh was eager to learn from other artists and experiment with a variety of techniques. He was strongly influenced by the stylized lines and expressive colors of Japanese woodblock prints. In 1886 he joined Theo in Paris, where he met French impressionists Henri Toulouse-Lautrec, Georges Seurat, and Paul Gauguin. Energized by the society and work of these innovative artists, Van Gogh began to incorporate the brilliant lights, colorful palette, and broad, sculpted brushstrokes of the impressionists into his paintings.

The intense art scene and bustle of Paris life began to exhaust and distract Van Gogh from his painting, and in 1888 he moved to the south of France, where he further developed his use of vibrant color, texture, and movement on the canvas. Letters and sketches he sent to family during this time include allusions to an encounter with a drake of the Rhône river. Although no known paintings of dragons by Van Gogh exist, these documents combined with his artistic struggle to understand and express the essence of man and nature are compelling arguments for his interest in dragonology.

# VAN GOGH MATERIALS

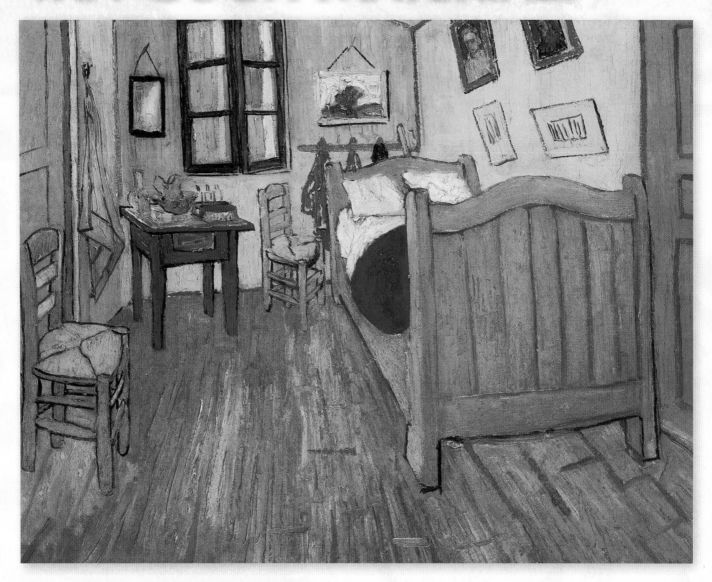

*Vincent Van Gogh, **The Bedroom**, 1889. Oil on canvas. Courtesy of Dover Publications, Inc. (Image from **120 Great Impressionist Paintings**.)*

At the turn of the nineteenth century, canvas and wood panels were the most common painting surfaces. Master artists covered them with a non-absorbent material to prevent paint from soaking deeply into the canvas or wood, and then they primed the painting surface with a white "ground" of lead, oil paint, or gesso. As mentioned in the Rubens chapter, traditional gesso ingredients may be difficult to locate today, so you can simply purchase acrylic gesso at your local art supply store. See "Priming Your Own Canvas" on page 45 for more information on preparing a support. The painting surface should be pliable in order to absorb later applications of oil paint and to prevent the paint from cracking.

## LEAD WHITE

*Artists of the past, including Van Gogh, used lead white, which produced a nice texture, but tended to dissolve over time. As a result, old paintings now appear much darker than they did originally. In addition, lead is an extremely toxic substance that is no longer used in paints. Many believe that Van Gogh's mental illness was a symptom of lead poisoning from the paints he used.*

To create a painting in the style of Van Gogh, I recommend using a canvas stretched on a frame, which you can either purchase or create yourself. As mentioned in an earlier section, a 16" x 20" canvas is an ideal size, as you can complete a dragon portrait fairly quickly and it is a convenient size for framing the finished work. Some artists, especially French impressionists, added various tones or hues to their canvasses before beginning a painting. However, it appears as though Van Gogh preferred working on a white canvas, leaving some parts untouched by paint to show through.

I suggest that you mix your own oil medium. To thicken your paints, mix equal parts drying linseed oil, bleached linseed oil, and liquine. In contrast, a good thinner consists of drying linseed oil, turpentine, and liquine. Both of these mixtures help your paints dry faster, and you should keep them on hand in metal containers as you work. The initial layers of paint should dry very quickly, as Van Gogh used an *a la prima* method in which most of the painting is done in one session. He was influenced by the impressionists, who captured immediate snapshots, or impressions, of what they saw or imagined. To paint in Van Gogh's style, you cannot allow several days of thoughts and distractions to influence your work.

For this project, you will use the same set of brushes as with the dragon portrait in the style of Rubens. Remember that it is very important to take care of your brushes and painting materials. Proper maintenance of your tools will build the discipline required to hone your skills as an artist and a dragonologist.

### COLOR AND EMOTION

*Van Gogh's use of color was an emotional expression of his interaction with the world around him. He placed primary colors next to their secondary complements, using the contrast to heighten their intensity (see pages 18–19 for more information on color theory). To reproduce these bold color effects, your palette should include the primary colors (red, yellow, and blue) and the secondary colors (green, orange, and violet). You should also keep black and white on hand for mixing. Although Van Gogh used lead white, the modern artist can choose between zinc white and titanium white, which is a brighter white.*

## PAINTING WITH A PALETTE KNIFE

*With painting knives, you can apply thick textures or render intricate details. Use the side of your knife to apply paint thickly. Use the fine-point tip of your knife for blending and drawing details. Below are some examples of effects you can achieve with a painting knife. Note: This is a technique Van Gogh often used.*

65

# PRACTICING WITH WATERCOLOR

Before you begin working with acrylic paints, it is helpful to practice Van Gogh's unique style with watercolors. The brushstrokes should be a mixture of long, flowing lines and shorter curved lines. Keep your hand relaxed and imagine you are using the brush as you would a pen or a wand.

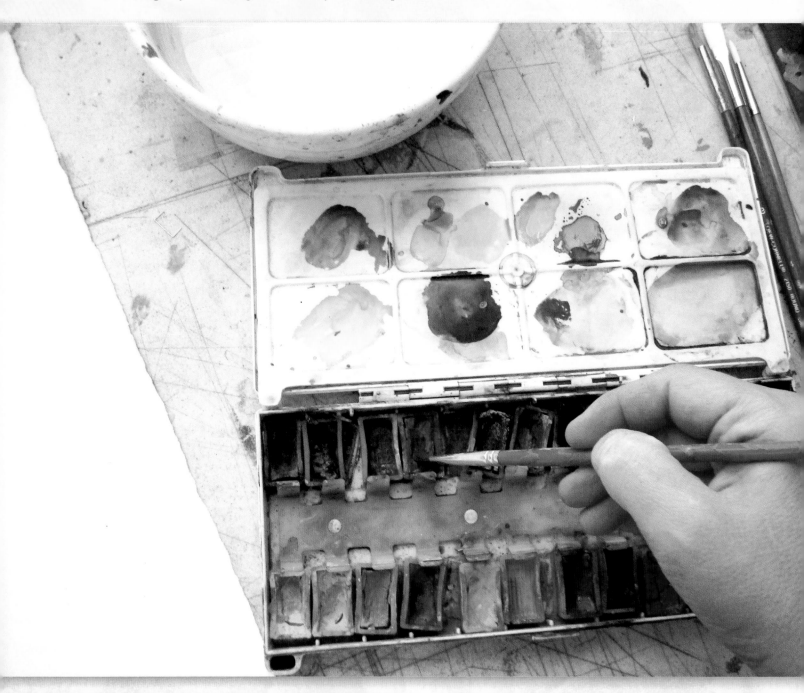

**WATERCOLOR SUPPLIES**

*Invest in a portable watercolor set to take into the field. All you need are your paints, a few brushes, a jar of water, and a cleaning rag or paper towels.*

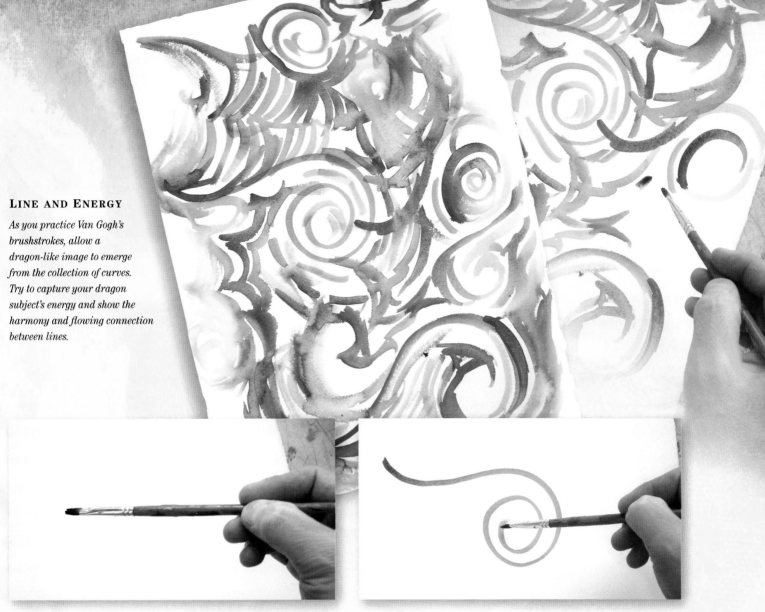

## LINE AND ENERGY

*As you practice Van Gogh's brushstrokes, allow a dragon-like image to emerge from the collection of curves. Try to capture your dragon subject's energy and show the harmony and flowing connection between lines.*

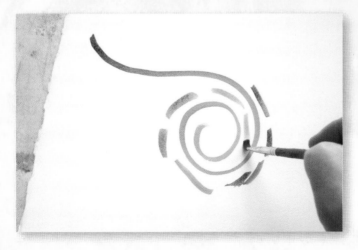

**Step 1** Use a sheet of high-quality watercolor paper and a small or medium round brush with a long handle. Hold the brush near its center for maximum control. This exercise is as much about holding the brush as it is about the strokes.

**Step 2** Use ultramarine or cobalt blue, as blue was Van Gogh's favorite color. Start with one of his signature curving lines, moving from left to right. Keep in mind that a slight movement of your hand will result in a greater movement of the brush tip.

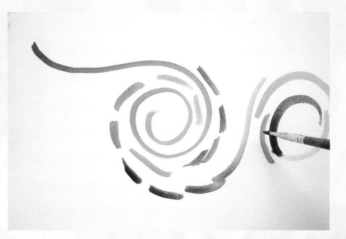

**Step 3** Repeat these flowing lines over and over. You can continue one curve into the next and vary your strokes with shorter curves. Free your mind, relax your hand, and practice different curling, waving, spiraling strokes.

**Step 4** You can work in layers or fill up entire pages with different strokes. Keep practicing until you are comfortable and confident with these curving brush movements. Imagine that you are portraying music, water, air, or clouds.

67

# CAPTURING A LIKENESS

Although many dragon species breathe fire, the East African Fire Dragon is unique in its ability to emit alarming degrees of heat from its scales. The cardiovascular system is able to regulate the dragon's core temperature so it does not overheat. It is suspected that ancient fire dragons spontaneously combust when their days are numbered. The many layers and colors of Van Gogh's style are well-suited for capturing the dynamic nature of this beast.

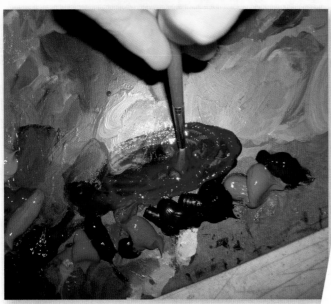

**Step 1** Dilute your ultramarine oil color to a transparent, almost watery consistency with the thinner solution described on page 65. Using the same brush and curvy strokes you practiced in watercolor, begin gently identifying the dragon's outline.

**Step 2** Try to portray your dragon subject amongst trees or foliage, as many of Van Gogh's paintings include these natural elements. Continue laying in the dragon's form and add a curling tail. All of your strokes should embody a musical, curving quality, creating a harmonious composition.

**Step 3** Using cadmium red, define the dragon's outline with broad, long strokes. When working in Van Gogh's style, always treat brushstrokes as lines and imagine that you are drawing with the paintbrush. These bold lines will hold the final image together.

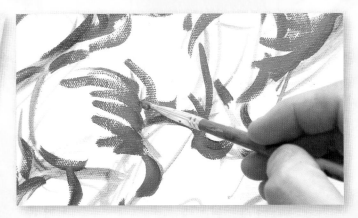

**Step 4** Apply red strokes throughout the painting, bringing out dominant shapes in the dragon, tree, and sky. Many of these red curves will show through the painting as lines later.

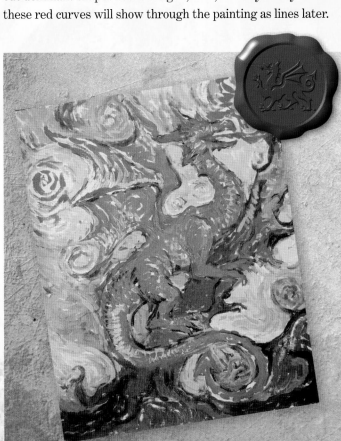

# FIRE DRAGON

| | |
|---|---|
| **HEIGHT:** | 50 FEET |
| **WINGSPAN:** | 120 FEET |
| **WEIGHT:** | 15,000 POUNDS |
| **HABITAT:** | EASTERN AFRICA |
| **DIET:** | AFRICAN WILD CATS, WILDEBEESTS, AND BLACK RHINOCEROSES; INHALES THE VOLCANIC GASES AT THE SUMMIT OF MT. KILIMANJARO |
| **POWERS:** | FLIGHT, SHOOTS FLAMES UP TO A DISTANCE OF 100 FEET, EMITS HEAT FROM ITS SCALES |
| **SCALE:** | |

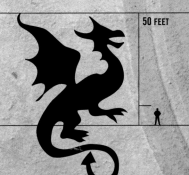

50 FEET

**Step 5** To save time and avoid constantly cleaning your brush, use two medium brushes of the same size—one for orange and one for cadmium yellow. You can mix the cadmium yellow with a bit of yellow ochre, but keep the colors pure and vibrant. Use a lot of paint and very little thinner for a toothpaste consistency; you are aiming for thick, three-dimensional brushstrokes. Start defining lines and shapes with orange, emphasizing the curviness of the dragon and echoing these strokes in its surroundings.

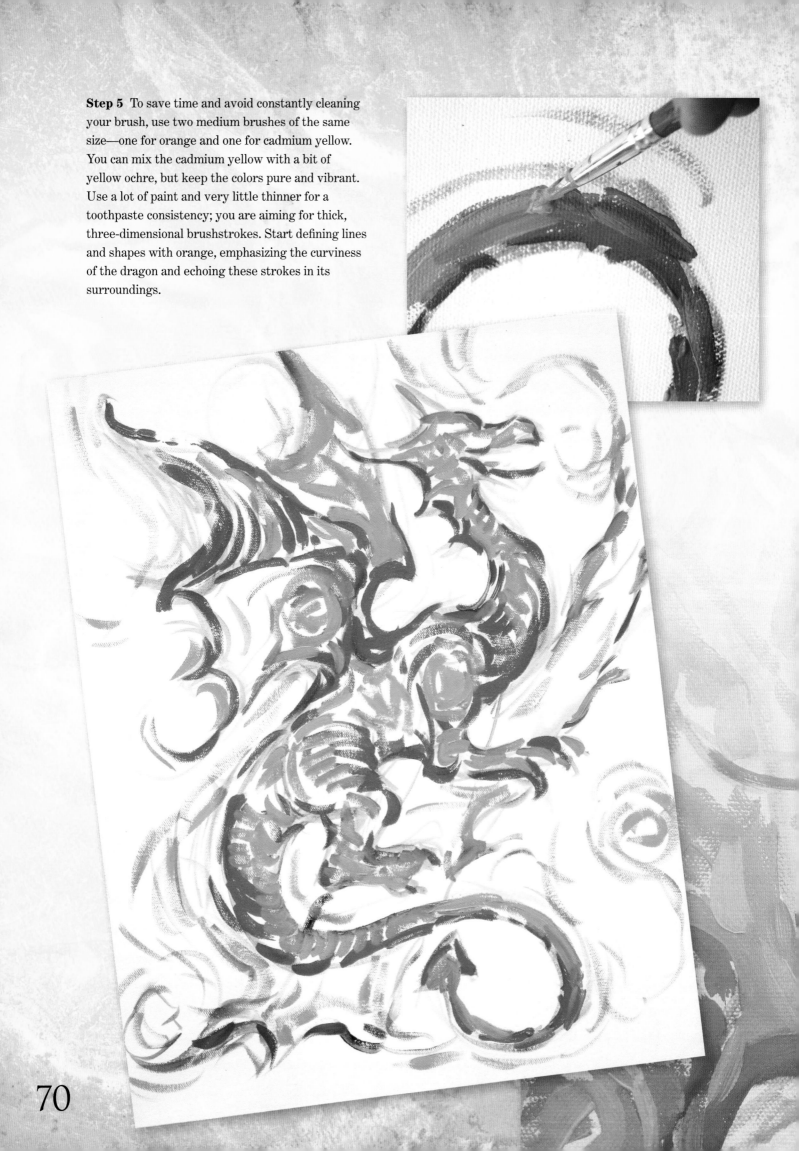

**Step 6** To capture Van Gogh's sparkling effect, create whirlpool-like shapes with yellow in the dragon's hip, wing, and throughout the sky, working from the center out. Let the warm colors flow into each other and apply each stroke with its close relationship to every other stroke foremost in your mind. Use a combination of long, curling lines and short, energetic dashes around the long lines. At this stage, the dragon's bulky form, tree, ground, and sky should be firmly established.

*Keep several images of Van Gogh's paintings nearby, allowing your brain and hand to connect with his energy and recreate his style.*

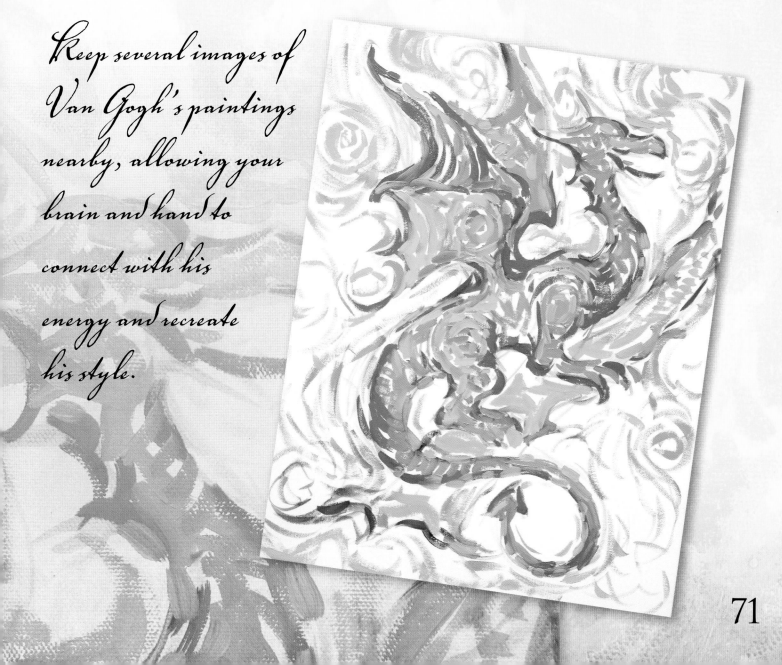

71

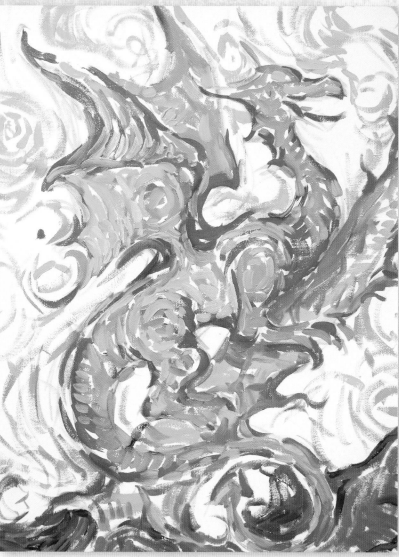

## BLENDING COLORS

*If necessary, mix a maximum of two colors together on your palette if you are trying to make a darker shade of a color. However, mixing colors on the canvas itself is a central impressionist technique. The viewer's mind will automatically blend two colors that are close together and perceive it as a new color.*

## CLEANING YOUR BRUSH

*You may clean your brush with a rag between applications of color, but with Van Gogh's style, unintentional mixtures of colors can result in "happy accidents" that add to the emotion and expressive qualities of the painting.*

**Step 7** Mix cadmium yellow with titanium white to create highlights in the dragon's wing, belly, and tail. Next use orange, light green, and dark green for the tree and grass. Define the outlines of these organic elements and echo the surrounding curves in the branches of the tree and the blades of grass.

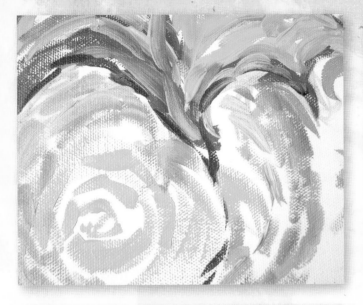

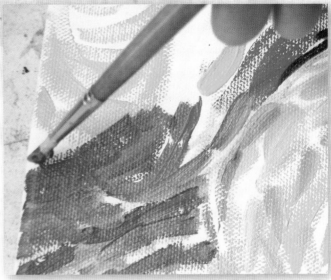

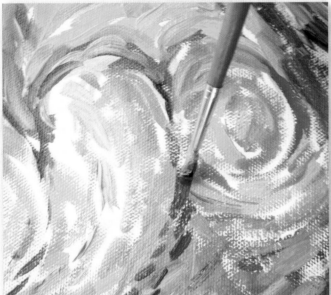

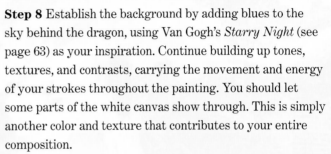

**Step 8** Establish the background by adding blues to the sky behind the dragon, using Van Gogh's *Starry Night* (see page 63) as your inspiration. Continue building up tones, textures, and contrasts, carrying the movement and energy of your strokes throughout the painting. You should let some parts of the white canvas show through. This is simply another color and texture that contributes to your entire composition.

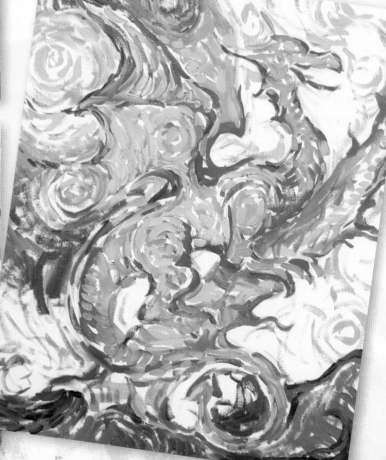

73

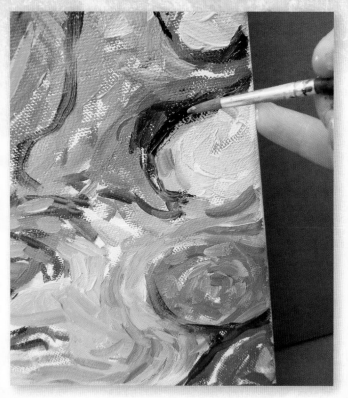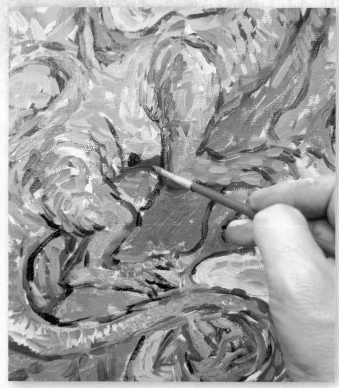

**Step 9** Add violet and more blues to the sky. Different gradations of blue and violet cause the warm reds, oranges, and yellows to pop out or have a floating effect, bringing the dragon into prominence. Develop the form of the sturdy tree with brown. Use a combination of thin and thick strokes for vibrancy and variety.

**Step 10** Now step back and take in the painting as a whole, looking for elements and details that you need to emphasize. Use a smaller brush dipped in ultramarine to define the dragon's neck, wing, legs, and tail. Define the shapes in the tree and grass as well, using short dashes rather than solid lines. The viewer's mind will connect the lines.

## DRAGON'S BREATH

*Many dragon's lungs are specially designed to store gases that can be expelled from their mouths and nostrils. Fire is the most well-known breath weapon, although different dragon species are able to breathe a range of substances, including frost, acid, and chlorine gas.*

**Step 11** Build up highlights in the dragon's tail and head, and use red to bring the horns forward. Continue defining lines and details with a small brush. The texture of the paint should be thick and buttery to create dimensionality and depth.

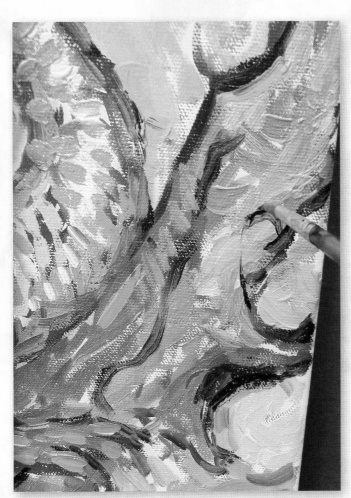

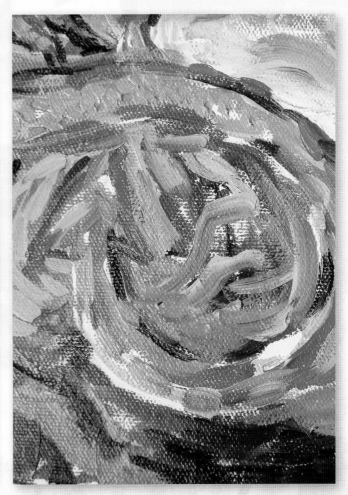

**Step 12** Build up highlights in the dragon's wing and tail to contrast with the darker, defined lines. Some elements, such as the flames coming from the dragon's mouth and areas in the clouds, can remain unfinished, but the painting should have an overall sense of completion and convey the dragon's and artist's energies.

# VAN GOGH, DIAGRAM OF AN ARTIST'S INNER LIFE

Considered to be one of the most successful artists in history, Vincent Van Gogh produced almost 900 paintings and over 1,000 drawings, sketches, and graphic works in just 10 short years. Ironically, Van Gogh only sold one of his paintings during his lifetime, and constantly struggled with doubts about his artistic abilities. Van Gogh also left behind thousands of letters to family and friends, giving us access to his feelings and views on a vast range of topics, as well as detailed accounts of his daily experiences.

Van Gogh had a very turbulent life, suffering from severe bouts of mental illness. Modern psychologists believe that he had bipolar disorder, which is characterized by extreme shifts between periods of deep depression and bursts of energized, manic activity. Van Gogh was intensely serious and socially withdrawn, and even his closest relationships were fraught with tension. His financial dependence upon his brother Theo and Theo's marriage produced feelings of anxiety and insecurity in Van Gogh. When his friend Gauguin visited him in the south of France, Van Gogh tried to attack him with a razor during a psychotic fit, and then cut off part of his own ear lobe. In 1889, he voluntarily admitted himself to the Saint-Rémy psychiatric hospital. However, he continued working during this time and produced over 150 paintings of the garden and fields around the asylum, as well as copies of his favorite artists' works. In May of 1890, Van Gogh was released from the asylum and moved to Auvers-sur-Oise, where he continued painting at a furious rate under the care of a homeopathic physician. Two months later, at the age of 37, Van Gogh walked to a wheat field near his lodgings and shot himself in the chest, leaving behind a collection of paintings that had a profound impact upon 20th century art.

His use of intense colors and energetic brushstrokes allowed Van Gogh to express his mental state while he was creating art. Each of Van Gogh's paintings is a precious gift to the aspiring artist, because it captures a master's emotions, his struggle with madness, and his artistic process. Utilizing Van Gogh's creative techniques in your dragon portraits will reveal the dragon's essence and your own inner state at the moment of creation.

## ELEMENTAL DRAGONS

*If humans and dragons could overcome our distrust of one another, humankind could benefit greatly from dragons' vast knowledge of and connection to nature. Some of the most ancient wyrms were considered gods due to their ability to control the elements. The following elemental dragons commonly work together to preserve nature's cycles of life, death, and renewal.*

***Earth dragons,*** *such as the Aztec fertility goddess Coatlcue, can affect crop growth and cause earthquakes. The Aztecs both feared and revered this powerful dragoness who could bring prosperity or destruction to their people. Earth dragons assist their neighboring plants and animals with the transitions between seasons.*

***Fire dragons*** *draw energy from the earth's magma. They can influence volcanic activity and expel fire from their mouths. In addition, they can withstand extremely high temperatures and the thermal radiation they emit is unbearable to humans within a 50-foot radius; so dragonologists must be careful to observe fire dragons from a safe distance!*

***Water dragons*** *have historically been worshipped for their rainmaking abilities, and they work closely with earth dragons to regulate plant growth and regeneration. Water dragons that live in colder climes work with ice, snow, and frost. As their body temperatures remain very low, slowing biological and aging processes, arctic water dragons tend to have a longer life expectancy than other dragons.*

***Air dragons*** *are able to control atmospheric pressure levels and start storms. Although they have no direct power over the other elements, they can produce strong winds that transport substances, such as sand, fire, ice, and snow, through the air. They also can create atmospheric barriers to protect themselves against enemies.*

# STUDYING PICASSO'S STYLE

Pablo Ruiz Picasso (1881–1973) displayed tremendous artistic ability at a tender age. His father, Jose Ruiz Blasco, was an art professor who recognized Picasso's skill and oversaw his early art education. Although Picasso's talent gained him admission to the leading art schools in Spain, Picasso skipped classes to visit local museums and soon gave up his formal education. At the age of 19, Picasso left home for Paris and his travels through Europe allowed him to explore diverse artistic movements and discoveries.

During his lifetime, Picasso experimented with a range of styles and subject matter. His early Blue Period paintings featured ill-fated lovers, mothers and children, as well as the downtrodden—including beggars, street girls, and the sick and elderly. These images were primarily done in somber, monochromatic blues and greens. Picasso then moved into his Rose Period, introducing a few brighter, warmer colors into his palette and focusing on street performers, circus artists, and harlequins. His contact with these misfits and outsiders may have introduced him to the underground world of dragonologists.

In 1907, Picasso met French painter Georges Braque. Together, they founded Cubism, a radical visual style that had a profound impact on 20th century art. Picasso was well-versed in traditional art

Reproduced by permission from Estate of Pablo Picasso/Artists Rights Society (ARS), New York. Pablo Picasso, **Self-Portrait with Palette,** 1906. Oil on canvas. Photo © Philadelphia Museum of Art/Corbis.

*Picasso's contact with misfits may have introduced him to the underground world of dragonology.*

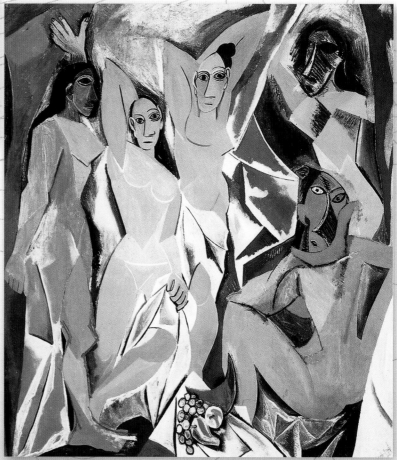

Pablo Picasso, **Les Desmoiselles d'Avignon,** 1907. Oil on canvas. Courtesy of Dover Publications, Inc. (Image from **120 Great Paintings.**)

conventions and the longstanding aesthetic ideal of accurately representing what is seen in nature, but he intended to break all of these rules! Paintings in this style clearly represent recognizable objects and human figures. However, subjects are broken down and analyzed as abstract, interconnected, geometric forms. Picasso continued to develop his artistic style throughout his life, but Cubism is his greatest legacy to an eager student of the great masters.

## THE DRAGON LIFECYCLE

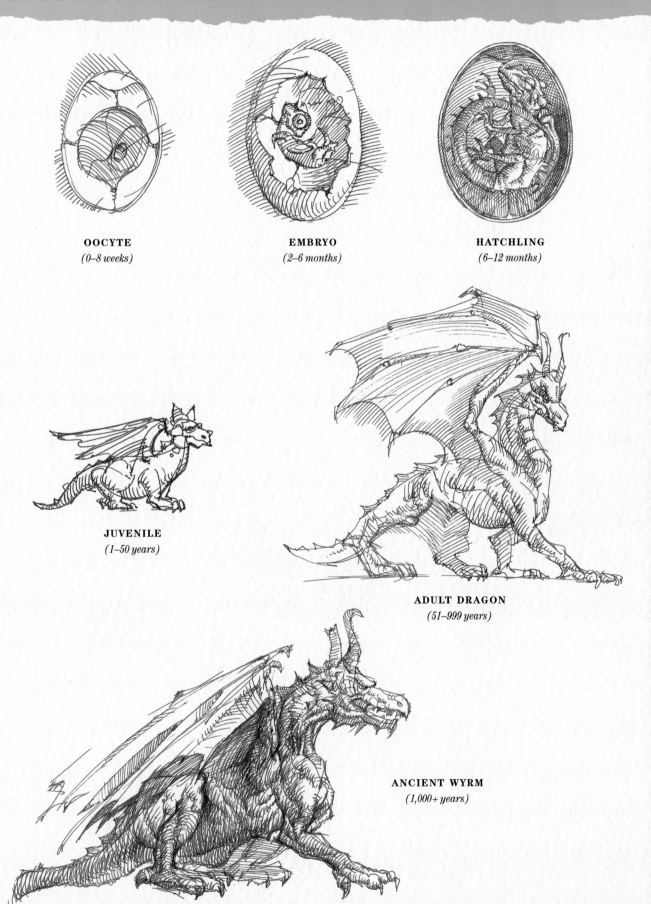

**OOCYTE**
*(0–8 weeks)*

**EMBRYO**
*(2–6 months)*

**HATCHLING**
*(6–12 months)*

**JUVENILE**
*(1–50 years)*

**ADULT DRAGON**
*(51–999 years)*

**ANCIENT WYRM**
*(1,000+ years)*

# THE PICASSO PALETTE

Dragonologists often complain that they have trouble finding the particular shade of paint needed to capture the radiance of a dragon's scales and the intensity of their fiery breath. The Cubist method is a wonderful way to depict the dimensions and brilliance of dragon anatomy. You will want to collect a wide selection of paints, as you never know what color the next dragon you discover will be. I thought I had seen it all until I crossed paths with a Fumo Drácon—his wings were blood red, with slashes of magenta, purple, gold, and even a dark green straight out of the Black Forest! Parménides Silva, an expert on this species, advised me that this dragon grows a different color of scales on its wings every century. The Fumo Drácon depicted in this guide is of South America origin, and his skin reflects the gorgeous light of a Brazilian sunset, as well as the remarkable shades of blue and green seen when flying past the coast of Chile. Although you may choose to use whatever materials you have on hand when on expeditions, select a high-quality paint for your final dragon studies. I prefer rich, creamy paints that mix easily. You can use the same brushes that you used for the Rubens piece in oil, although brushes with synthetic bristles are also available for acrylic painting.

*This chilling green color always reminds me of the blood of the Fumo Drácon.*

You will find that acrylic paints dry very quickly and have a glossy finish. Although Picasso primarily used oil paints, you may find that working with a faster-drying paint will allow you to more easily render the distinct forms, lines, colors, and textures that characterize his most popular works in your dragon portraits.

This style of painting requires two color palettes, one with cool colors, and one with warmer tones. I like to use two separate paint palettes for acrylics because they tend to require a lot of space. If you are traveling light, you may prefer to use cold-pressed watercolor paper instead of a proper palette; it is light-weight and won't warp. Be sure to properly care for your brushes and never let them dry out with paint on them! Lay brushes flat in a shallow tray of water between uses during a session, and wash them as soon as you are done painting, as it only takes 20 minutes for acrylic paint to dry.

## ACRYLIC MEDIUMS

*The only medium you really need for acrylic paints is plain water. But flow improver can help you create manageable mixtures. Thin your mixes with water or medium to make* washes—*thin, somewhat transparent coats of paint. Add more water or medium to lighten a color and less water to deepen it. When painting a wash, it's also helpful to apply water to your painting surface with a brush, sponge, or mist sprayer. This will make acrylic paint bleed and create a soft look. If the surface is dry, your brushstrokes and color applications will be more controlled and have harder edges.*

### FLOW IMPROVER

*You can use flow improver anytime you want your paint to flow more easily over the support. Although the medium looks milky white in color, it will become transparent when dry.*

Acrylic Flow Medium

## ACRYLIC TECHNIQUES OF THE MASTERS

### FLAT WASH

*A flat wash is an easy way to cover a large area with a solid color. Load your flat brush with diluted paint, and—holding your support at an angle—sweep the color evenly across in successive strokes. Add more paint to your brush between strokes, and let the strokes blend together.*

### GRADED WASH

*A graded wash graduates from dark to light, which makes it a perfect technique for depicting water and skies. Use your flat brush to paint horizontal strokes across a tilted surface, just as you would for a flat wash, but add water to each subsequent stroke to gradually lighten the color.*

### DRYBRUSHING

*Drybrushing is great for creating texture in paintings. First paint an even layer of color and wait for it to dry. Then load your brush with a new color, remove excess paint with a paper towel, and stroke lightly over the first layer, allowing the underlying color to show through.*

### THICK ON THIN

*Another way to texturize your paintings is to add a thick layer of paint over a thin layer. First apply a thin, transparent wash to establish your "ground," or base color. Then paint thickly on top, leaving gaps to let some of the undercolor show through, which creates the illusion of depth and texture.*

### SOFT BLENDS

*To create soft blends, use a soft, flat brush and gentle brushstrokes. Paint even, overlapping layers on your support, varying the direction of your brushstrokes to evenly blend the colors and hide your brushstrokes.*

### THICK BLENDS

*You can achieve interesting effects by mixing thick acrylic paint directly on your support with a flat, wet brush. For example, in this demonstration, blue and yellow gradually blend to form green, creating a soft, loose blend. This type of gradual blend is great for painting subjects in nature.*

# THE ART OF THE LINE

Many of Picasso's most famous works used an abstract, free-hand style. Although it may look as though a young dragonologist drew these sketches in a dark cave, they follow Picasso's belief that it is important to capture your subject using as few lines as possible. Each stroke of the pencil should be purposeful and firm. The lines should be continuous; try to draw a portrait without lifting your hand from the paper. Try to resist using your eraser when making these sketches. The more sketches you do, the better results you will achieve. Experiment with different angles and compositions, concentrating on emphasizing the majestic silhouette of the dragon. To practice this technique, relax your hand, relax your mind, and let your subject inspire you. (As always though, I must remind you to not get too carried away—dragons may make very inspiring subjects, but they will not hesitate to eliminate a perceived enemy. Don't allow your mind to drift or let your guard down, if even for a moment!)

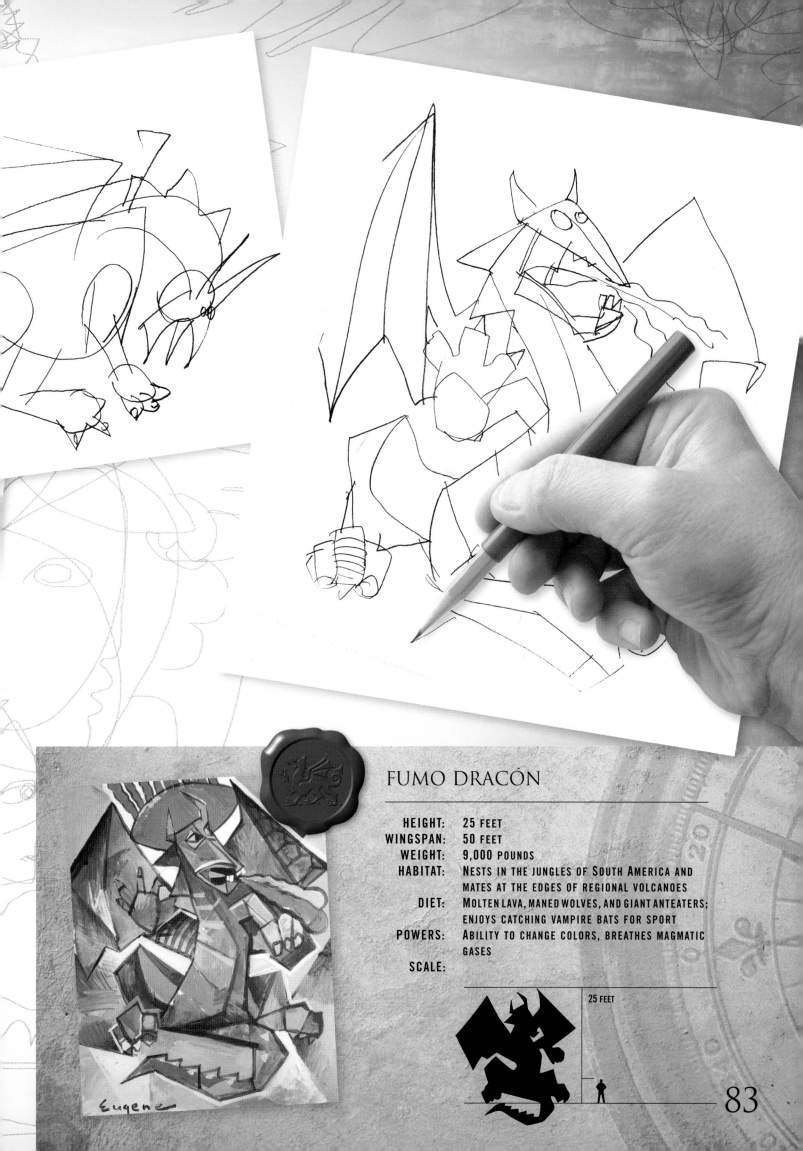

# FUMO DRACÓN

|  |  |
|---|---|
| HEIGHT: | 25 FEET |
| WINGSPAN: | 50 FEET |
| WEIGHT: | 9,000 POUNDS |
| HABITAT: | NESTS IN THE JUNGLES OF SOUTH AMERICA AND MATES AT THE EDGES OF REGIONAL VOLCANOES |
| DIET: | MOLTEN LAVA, MANED WOLVES, AND GIANT ANTEATERS; ENJOYS CATCHING VAMPIRE BATS FOR SPORT |
| POWERS: | ABILITY TO CHANGE COLORS, BREATHES MAGMATIC GASES |
| SCALE: | |

25 FEET

# CAPTURING A LIKENESS

The inner nature of the Fumo Dracón is well represented by sharp angles and large planes, making the Picasso style well suited to this portrait. This is a smaller dragon than some, but do not underestimate its ferocity. I made this mistake many years ago and was fortunate enough to live to regret it, though I no longer have eyebrows.

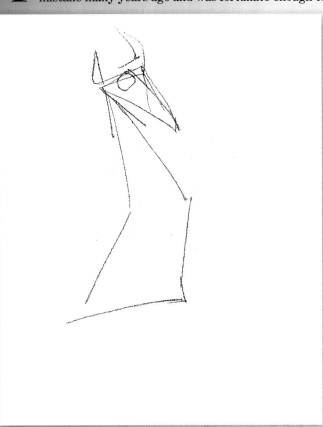

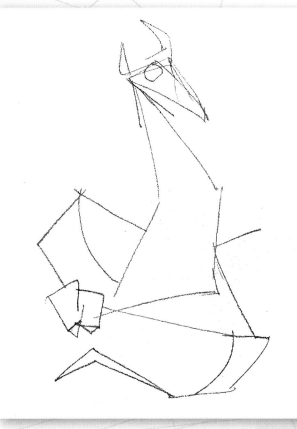

**Step 1**  Begin to copy your sketch onto a 16" x 20" canvas, starting with the body and the head. I prefer to use a small piece of firm, black charcoal as I find it helps connect my brain to my hand.

**Step 2**  Develop the base of the dragon, keeping in mind the composition of the canvas. Make sure to balance the distance between the edge of the dragon's outline and the edge of the canvas.

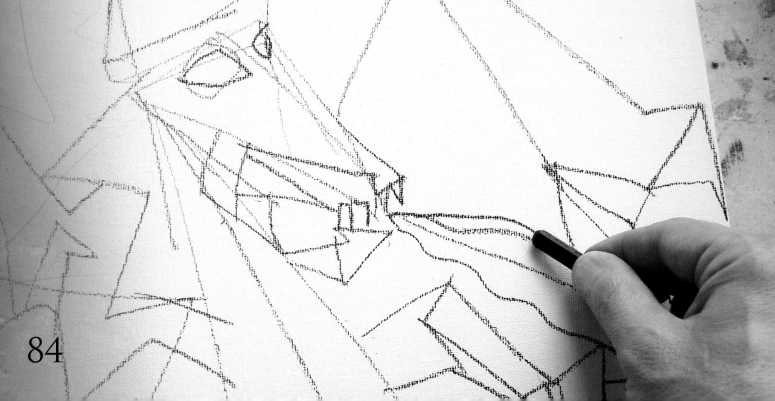

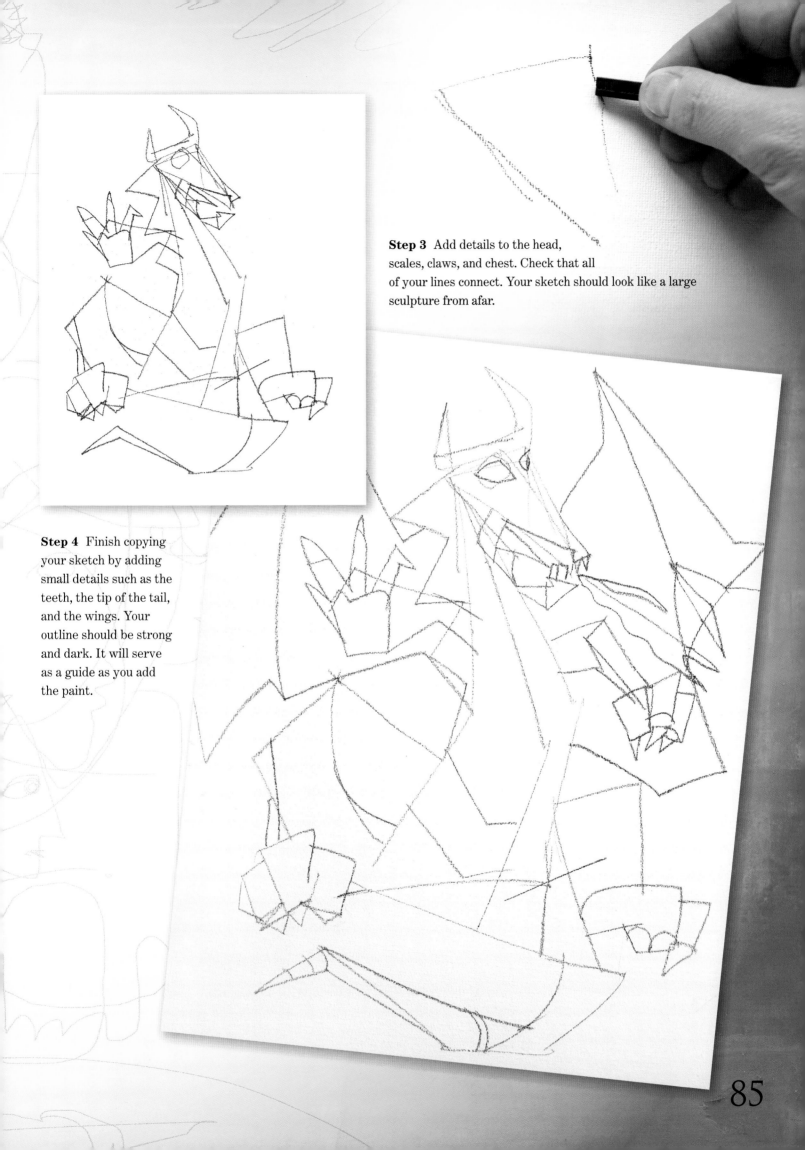

**Step 3** Add details to the head, scales, claws, and chest. Check that all of your lines connect. Your sketch should look like a large sculpture from afar.

**Step 4** Finish copying your sketch by adding small details such as the teeth, the tip of the tail, and the wings. Your outline should be strong and dark. It will serve as a guide as you add the paint.

# THE DRAGON DIET

Most dragons are omnivorous and consume a variety of plants and animals native to their habitat. It is uncommon for dragons to kill livestock or seek out human prey. However, with the extinction of many animals due to hunting, pollution, and urban development, dragons have often been forced to rely on alternate food sources, such as domesticated animals. In addition, there are certain species of dragons in Europe and South America that have acquired a taste for humans as a result of receiving unsolicited human sacrifices.

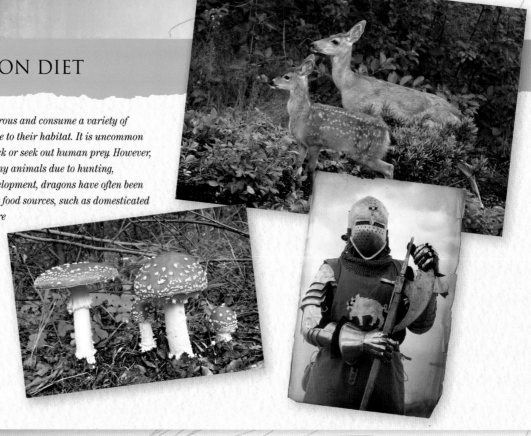

**Step 5** Use your finger to blend the charcoal to create shadows. This will add dimension to your sketch and guide you as you choose paint colors.

**Step 6** Charcoal sketches do not withstand the elements well. To prevent wind, fire, or paint from disrupting the sketch, spray a high-quality fixative over your sketch.

## THE DRAGON HOARDING INSTINCT

Contrary to popular belief, dragons are not avaricious monsters. In ancient times, dragons were appointed as the guardians of objects imbued with powerful magic and warned that these items should be kept safe from warmongering humans at all costs. However, humans sometimes learn of the existence of these enchanted relics, such as the Holy Grail that is purported to grant eternal life to its keeper. Dragons also collect gemstones and precious metals, as these objects are forged from the earth's most pure elements and contain old magic. Thus, stories of dragons as evil hoarders were most likely circulated by fortune hunters eager to get their hands on the treasure protected by these guardians.

*Pablo Picasso*

# WORKING WITH ACRYLICS

Once you have completed your sketch of the Fumo Dracón, you can begin to add color, using the acrylic paint. The colors can be vibrant, powerful, and varied, reflecting this dragon's rich heritage and ties to modern chameleons.

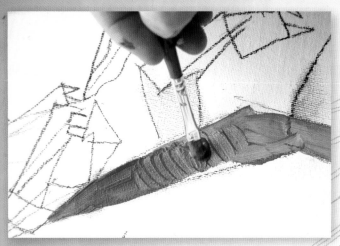

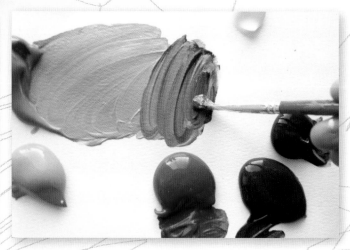

**Step 1** Begin by mixing an earthy brown palette that reflects the colors that Picasso learned to favor after studying the masters of the renaissance. I prefer mixing mars brown and sienna. Avoid mixing more than three colors at a time, but don't be afraid to mix your paints directly on the canvas, instead of on the palette. Use the brown tones to add a base of color to the major shapes of the dragon. Experiment with different brushstrokes, alternating between long and short strokes.

*Treat your charcoal sketch as the frame of a stained-glass window.*

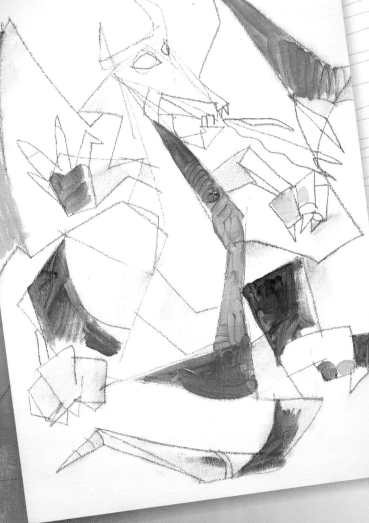

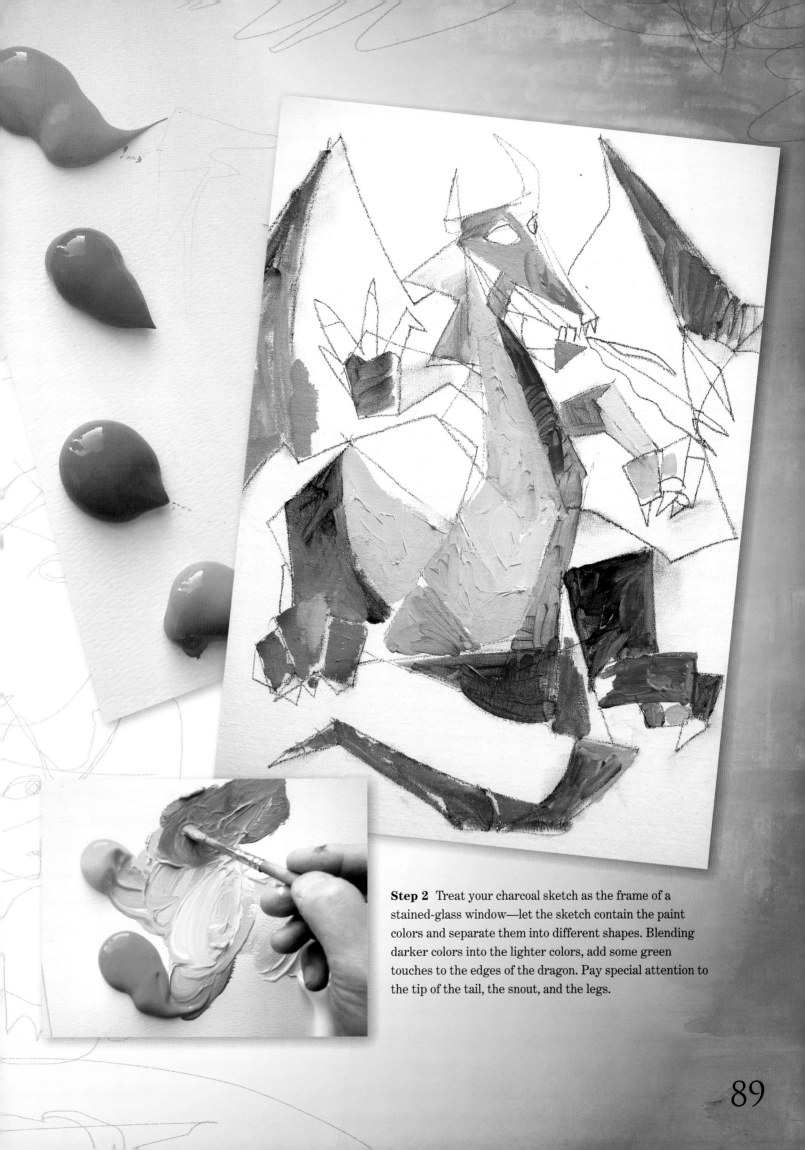

**Step 2** Treat your charcoal sketch as the frame of a stained-glass window—let the sketch contain the paint colors and separate them into different shapes. Blending darker colors into the lighter colors, add some green touches to the edges of the dragon. Pay special attention to the tip of the tail, the snout, and the legs.

89

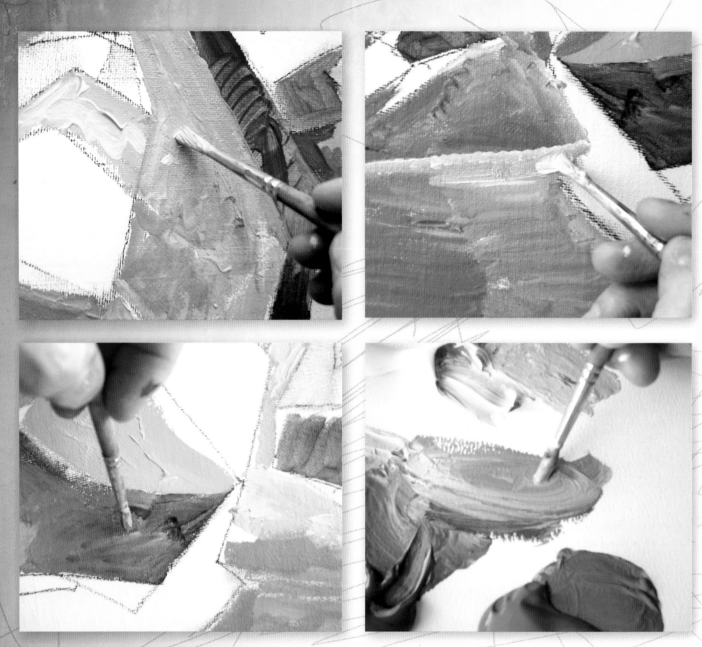

**Step 3** Now it's time to add cooler colors to your painting. Mix in violet, gray, and even small amounts of black to the undersides of the dragon's body and wings. Use very short brushstrokes to make the painting more three-dimensional and sculptural.

## DRAGON EXTREMES

*Although dragons are extraordinary creatures in general, there are a few species with exceptional features:*

**Longest wingspan:** *120 feet, East African Fire Dragon*
**Fastest on land:** *85 miles per hour, Acinonyx Dragon*
**Fastest in the air:** *100 miles per hour, Frigate Dracón*
**Fastest in the water:** *75 miles per hour, Velumus Draco*
**Tallest:** *60 feet, Jotnar Drache*
**Most intelligent:** *IQ of 215, Eastern Lung*
**Most amazing ability:** *Teleportation, Kinesia Dragon*

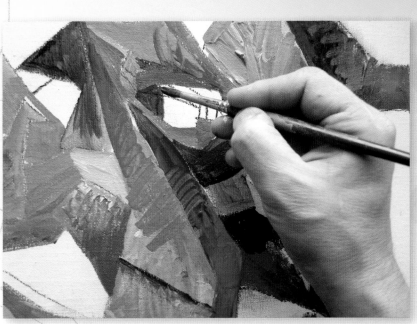

**Step 4** Add blue shades to keep the colors fresh. Mix ultramarine blue, chrome blue, and cerulean blue and add streaks of blue to the head, wings, and body. Imagine you are sketching with your brush. Picasso favored using the *a la prima* technique. Meaning "done all at once" in Italian, the *a la prima* technique creates a fresh painting where the artist works quickly, constantly moving over the canvas—left to right and top to bottom. This technique is especially appropriate when painting an active beast like this Fumo Dracón.

**Step 5** Take breaks while you work—walk away from the canvas to get a fresh perspective. You can even perform an artist's squint to look at the balance of the colors, the lighting, and composition. When I am in doubt of what to do next, I always find that a good squint helps me to see the way forward.

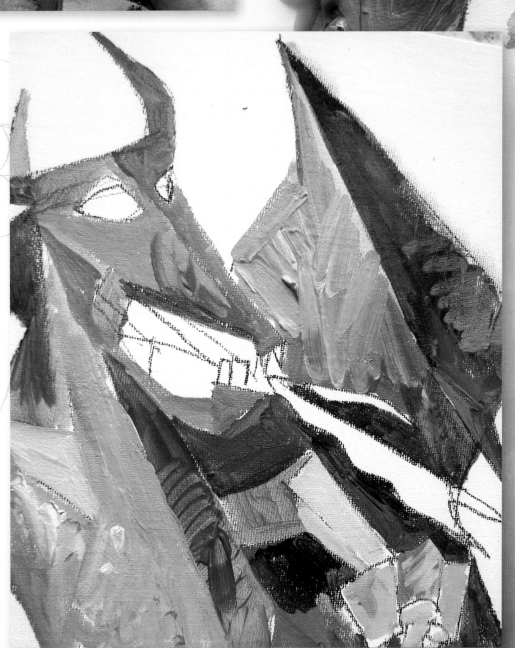

91

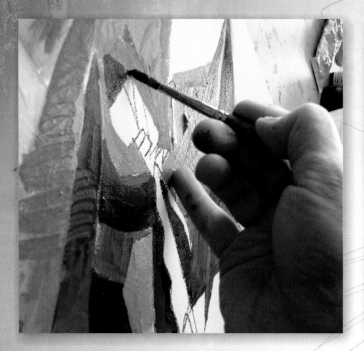

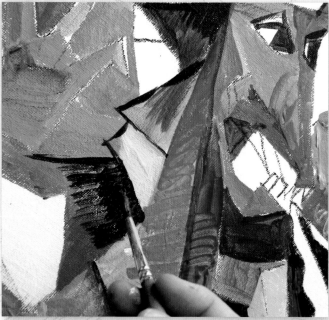

**Step 6** To emphasize the stained-glass effect, go over the black charcoal lines that you drew earlier with black paint. The line can be dark and thick in some areas and thinner in others. I find it helpful to imagine that I'm using a calligraphy pen when creating the outline.

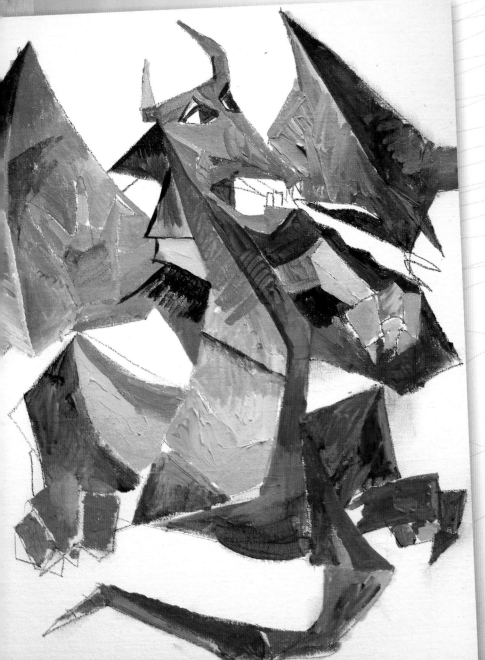

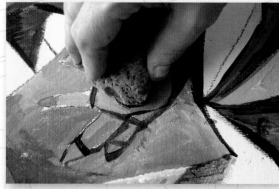

**Step 7** Now is the time to experiment with details. I tried replicating a spiral tattoo I saw on the dragon's clawed arm, but decided that I wanted to keep the painting simpler and focus on the fiery nature of the dragon. If you decide to remove an element, just use a damp sponge to wash off the paint before it dries. You can always paint over an area until you're satisfied with it too.

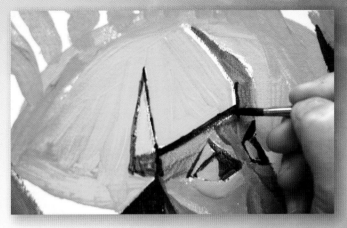

**Step 8** Add white highlights to the claws and legs and outline the edge of the tail with red to draw attention to this powerful weapon.

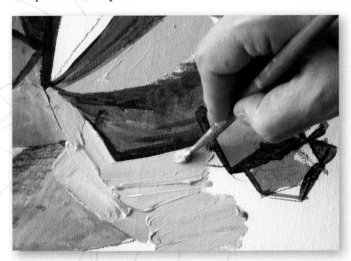

**Step 9** To create the background use the same colors that you used to paint the dragon, adding in a bit of titanium white paint to soften the colors. Use geometric blocks of color to continue the Cubist theme. Leave some room at the base of the canvas to add a base for the dragon to rest upon.

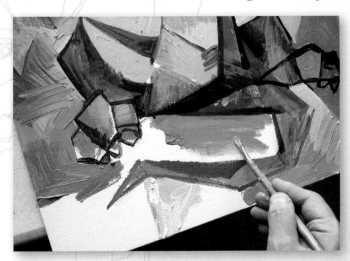

**Step 10** Paint in a rocky cliff to ground the dragon, and leave space to sign and date your masterpiece!

**Step 11** Add a few more touches of pure titanium white to the dragon's head to emphasize its long snout. Also paint in the bright, yellow meteorite behind the dragon's head. Add a few dark lines to the wings to give them more depth and separate them from the background.

# PICASSO, THE MODERN ARTIST

No other artist in history has experienced as much recognition and attention during his lifetime as Picasso, who established himself as a legendary figure of twentieth century art. Art historians believe that his artistic genius influenced nearly every aspect of modern art. He produced a vast amount of artwork in a range of media, including over 10,000 paintings and numerous sketches, drawings, printed graphics, ceramics, and sculptures.

We can also learn from Picasso's contributions to the science of dragonology. Picasso's father specialized in paintings of birds and other animals, and it is perhaps this early exposure to the study and depiction of wildlife that led Picasso to his interest in dragonology. From his childhood sketches, we know that Picasso enjoyed drawing bullfights and birds. His later works, such as the famous painting *Guernica*, feature the minotaur, another creature shrouded in mystery and deserving of careful study. Many dragonologists believe that Picasso undertook several expeditions throughout Europe to observe dragons, his bold self-assurance taking him into the lairs of the most lethal fire-breathers. Testimony from his close friends suggests that evidence of Picasso's fieldwork is among the many art pieces he kept for himself and deemed too important to share with the general public. Even if dragonologists never gain access to his fieldwork, we can look to Picasso's revolutionary methods of portraying natural forms as an exciting approach to analyzing and understanding complex dragon subjects.

—Inyo Press—Thursday, February 23, 1933

## GIANT REPTILIAN CREATURE ON THE LOOSE

*By Edgar Vlieger*

Inyo County—Early yesterday morning, hikers on the east side of the Mt. Whitney trail near Lone Pine Lake saw strange tracks on the ground. The unusual footprints measure over 20 inches in length and appear to be the imprint of a large reptilian creature with three claws. Upon following the tracks, the curious hikers found that the claw prints abruptly end approximately 55 feet from the trail with no indication of where the animal headed next or how it could have left the area without leaving behind further tracks.

In the past few weeks, witnesses in the areas surrounding Inyo National Forest have reported sightings of a large, winged creature resembling a lizard near the summit of Mt. Whitney that is estimated to have at least a 30-foot wingspan. These reports, along with the tracks discovered yesterday, have scientists baffled. The only animals of a similar size and description that were able to fly were the pterosaurs, a family of flying lizards from the time of the dinosaurs. Both herpetologists and paleontologists are working frantically to determine whether the mystery animal is an as yet unclassified reptile or the surviving relative to a prehistoric creature.

*Visited site March 15, 1933. Found abandoned green dragon lair 3 miles from tracks. Scientists and hikers nearby prevented more thorough investigation.*

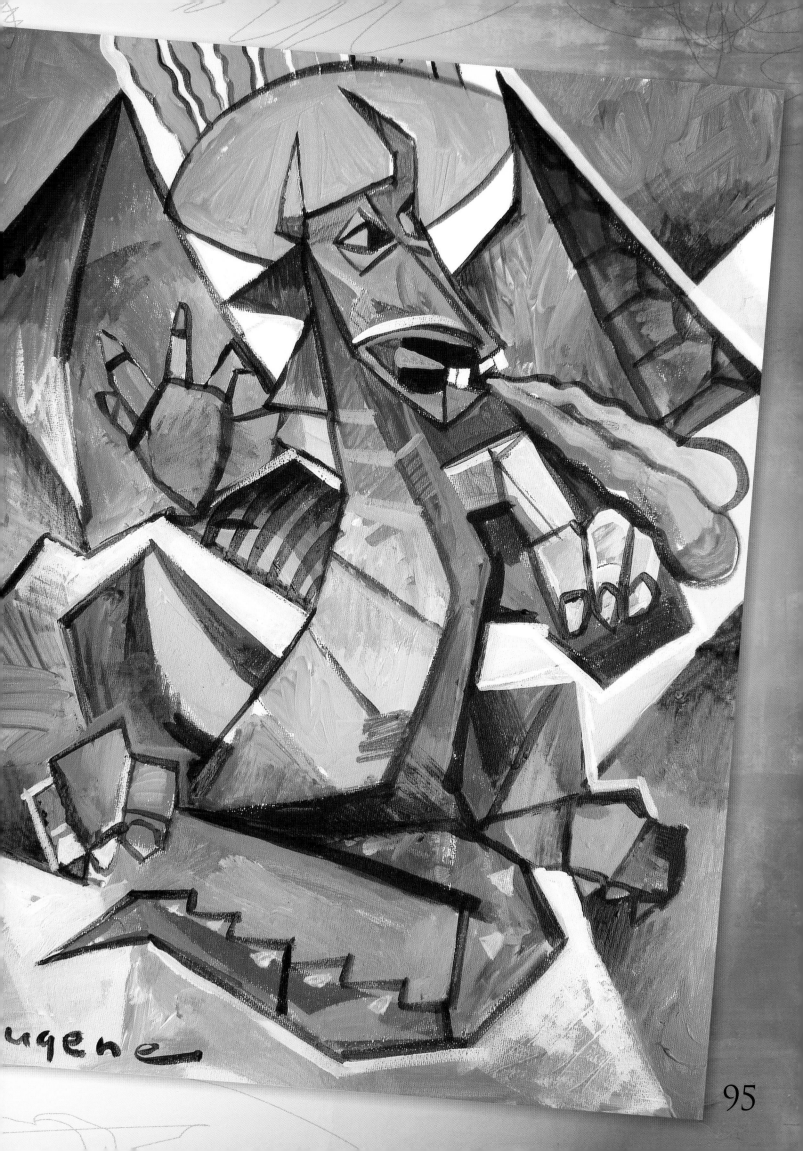

ugene

95

# Oath of the Masters

I, _____, understand that I have been entrusted with a collection of rare and precious manuscripts. I commit to learning the great masters' artistic secrets within these hallowed pages by drawing daily and earnestly practicing the masters' techniques and styles.

I, _____, further understand that the information regarding dragons I now possess comes with great responsibility. I commit to using this knowledge for the sole purpose of advancing the study of dragonology and dragon portraiture.

I, _____, agree to scrupulously guard these manuscripts against those who might use the contents to obtain fame or fortune.

_____
Signature

_____
Date